GW00471172

SLICES

OF

INFINITY

F. W. Boreham

John Broadbanks Publishing
Eureka, CA
2016

John Broadbanks Publishing
Eureka, CA
2016

10 9 8 7 6 5 4 3

Printed in the United States of America

ISBN-13 978-0-9975974-1-7
eISBN: 978-0-9975974-2-4

Cover Design: Laura Zugzda
Layout: Marcia Breece

*If a man wants to feel that the world is wide,
and a good place to live in, he must be
for ever and for ever sampling infinity.*

F. W. Boreham,
"A Slice of Infinity,"
Mushrooms on the Moor (London:
Charles H. Kelly, 1915), 11-20.

Table of Contents

FOREWORD

S oon after starting to pastor the Mosgiel Baptist Church, F. W. Boreham confessed to his mentor that he was homiletically bankrupt. To which, J. J. Doke gave the young preacher this advice: "Read. Read my dear man! Read systematically and keep on reading: never give up." Following Doke's practice of buying and reading at least one substantial book a week, F. W. Boreham not only regained solvency but he amassed such imaginative wealth that he became a master preacher, a much-loved editorialist and a best-selling author.

When we consider in this new volume of essays the scope of F. W. Boreham's subjects—explorers, poets, scientists, diplomats and teachers—we recognize the voracious reader that he became.

Trained as a journalist, he applied his investigative powers to dig up intriguing details and highlight the surprising twists and turns that shape his subject's life. He often reveals the sources of his inquiry, and with economy and beauty F. W. Boreham synthesizes sizeable slabs of material into polished 1,000 word cameos.

F. W. Boreham was not only a careful researcher but a passionate reader who strove to encounter authors through their pages. F. W. Boreham displayed this depth of engagement when he wrote: "I believe in the immortality of the soul! How can I doubt it when, in books like this, I actually hold palpitating fellowship with the man whose body was committed to the grave a hundred years earlier."

I was rummaging through the Whitley College archives one day when I stumbled across two cartons of books that contained F. W. Boreham's personal copies of his 55 books. Among the other items of memorabilia I found the plan in Boreham's handwriting of the structure of the book he was compiling at the time of his death, in which he was drawing together one newspaper editorial that was connected to each day of the year. It is from this plan that this volume of editorials has been drawn.

Enjoy sampling these "slices of infinity."

Geoff Pound

THE LIFE LUXURIOUS

In Lent we are asked to eschew luxuries. But what is a luxury? That is the very pertinent question which, in all the elaborate disquisitions about thrift, simplicity, and austerity, nobody has seriously attempted to answer. But, until that question has been bluntly asked and frankly answered, the discussion will resolve itself into a haze of platitudes, a volley of blank cartridge, a futile beating of the air. The orator who declaims vigorously against the luxurious life pleases everybody but persuades nobody. His denunciations elicit round after round of applause, but they lead to no practical or useful effect. The reasons are simple enough. Smith, Jones, and Robinson listen sympathetically to his eloquence. Smith, who draws a salary of £300 a year, and whose only form of indulgence consists in an occasional visit, with his wife and family, to the cinema, takes it for granted that the speaker is directing his fire upon Jones, who, with an income of £600 a year, is able to fare more sumptuously, dress more elaborately, and take life more easily than he himself can possibly do. But no such thought crosses the mind of Jones. He thinks at once of Robinson who, on a still ampler income, is in the habit of gratifying much more splendid tastes. And so ad infinitum.

The real trouble is more deeply seated. Humanity has an odd trick of regarding its tyrants as its benefactors. And, up to a certain point, our luxuries are undoubtedly tyrannical. Like the Old Man of the Sea in the Arabian Nights Entertainments, we pick them up with a smile, but, afterwards, find it impossible to shake them off. A fresh sensation swims into our ken. It promises us additional pleasure or additional comfort. Its novelty captivates us and we make some sacrifice to acquire it. Six months later the novelty has worn off, and the normal course of life is no more felicitous than it was in the old days before the new contrivance made its appearance. Yet to part with it would appeal to us as a real deprivation. Luxuries of one day become necessities of the next.

Luxury Not Necessarily a Matter of Money

What, then, is a luxury? Is it, of necessity, a thing that costs money? John Ruskin would indignantly deny it. "To watch the corn grow; to see the blossoms set; to draw hard breath over spade or ploughshare; to read; to think; to love; to pray; these," he declares, "are the things that make men happy." Towards the close of his life, Henry Ryecroft marshaled, in grateful retrospect, all the more joyous experiences he had ever known; and, in doing so, the thing that really amazed him was the fact that the pleasures that had proved most satisfying and most memorable were the pleasures that had come to him without money and without price. His strolls in the country lanes; his long familiar chats with congenial companions; his relish of common foods and simple fruits; his enjoyment of certain books picked up cheaply at a second hand stall; his memories of gorgeous sunsets

that transfigured sea and land, of moonlight nights when the fields sparkled with the frost and the river was like a stream of molten silver, of the russet tints of Autumn and the delicate sweetness of Spring; it was a medley of such images that rushed back upon his mind as he took stock of life's lordliest treasure and made him wonder that he had ever wasted his substance on more expensive delectations.

One of the few concrete definitions of a luxury is Mr. Stuart White's. In his *Blazed Trail* he declares boldly that a luxury is the exquisite savor of a pleasant sensation. The most delicious moment in his experience, he adds, was the springing up of a cool breeze towards the close of an insufferably sultry day. "Never," he adds, "have dinners or wines or men or women or talk of books or scenery or adventure or sport or the softest, daintiest refinements of man's invention, given me the half of luxury I drank in from that little breeze." And he goes on to argue that the commonest things—a dash of cool water on the tired wrists; a gulp of hot tea; a warm, dry blanket; a whiff of tobacco; a ray of sunshine—are more really the luxuries of life than all the intricacies and sybaritisms that we buy.

Luxury as a Question of Appetite

Obviously, therefore, many of our vaunted luxuries are luxuries only in name. We tack them on to the already burdensome paraphernalia of life, not because they afford us genuine satisfaction, but because of a vague suspicion that it is correct, and therefore desirable, to acquire them. It is, as Mr. Gladstone used to affirm with withering scorn, the play of our imitative instinct. Is it not significant that, when we whole-heartedly abandon ourselves to pleasure

and repose, we leave all our so-called luxuries behind us? We get away into the solitudes of the bush, or seek some lonely beach; we don old clothes; we spread a tent above our heads; we live on what we ourselves catch and cook; and, with a perceptible inward chuckle, we snap our fingers at civilization and all its ways. We feel it to be a salutary thing to woo back the simpler appetites.

Is it not possible that we have become like the unhealthy child who, scorning plain, wholesome food, peevishly whimpers for sweets and confectionery? Which is the truer luxury, to pamper his cloyed palate with the trifles that it craves, or to restore to him an appetite that will render him ravenous for simpler and more nutritious food? It may be that the fiery ordeals of these critical times will eventually teach us that the luxuries of life lurk among its simplicities, and that, as existence becomes less complex, it may, at the same time, become more delightful. After all, there is no valid reason for excluding our own era from the application of that greatest sermon ever preached—the Sermon on the Mount—with its dramatic contrast between the elaborate but minor happiness of Solomon in all his glory and the simpler but major felicity of the creatures of the wild.

A CONTINENTAL DREAMER

Cecil Rhodes was one of the most disturbing, one of the most commanding and one of the most creative figures of a singularly eventful epoch. Happily, we are now able to review the extraordinary career of Cecil Rhodes in a more just and accurate perspective than was possible when, with the dust and smoke of the South African conflict still in the air, the remains of the great statesman were interred on the lonely crest of the Matopos. Dying, not yet 50, amid the turmoil created by the Boer War, the issues were so confused that men found it difficult to make up their minds as to his claims upon their admiration. To few men, however, are the years that follow death kinder than these 50 years have been to the memory of Rhodes.

The reading of his will was a revelation in itself. That historic instrument is the most imposing example on record of the high art of counting one's chickens before they are hatched. Rhodes drew up his famous will at the age of 22. His fame and his fortune were alike things of the future. Yet, in this breath-taking yet characteristic document, he deliberately proposes to himself, as the loftiest ideal possible of actual attainment, the world-

wide spread of British culture as the most wholesome and uplifting influence in the evolution of human history; and he closes by bequeathing everything of which he possessed to schemes that will further this end.

Making Life Easier for Successors

His reasons for these daring testamentary dispositions were rooted in his own youthful experience. At the age of 18 he had left England and gone out to his brother's farm at Natal. Here he dreamed a rainbow-tinted dream, and, at the same time, made two important discoveries. His dream was a dream of a newly constituted Africa—an Africa with all its jangling elements and alien territories happily united and with an open road right through to the Mediterranean. Of his discoveries, the first was that it is comparatively easy, under favorable circumstances to make money; the second was that, to make the most of one's opportunities, a man needs a first-class education. He decided that, without severing his association with South Africa, he would take a university course—and a degree—at Oxford. He dashed home in 1873, in 1876, in 1877 and in 1878 and eventually took his M. A. degree at a time when he was already chairman of the de Beers Mining Co. and a member of the Cape Parliament. To make this phase of life a little easier for other men than it had been to him, he determined to scatter scholarships like snowflakes all over the world; and, in his boyish will, he made the necessary provision.

Greatness and Gentleness Blended

No man was more misunderstood. He was regarded as taciturn, crafty, passionless, designing; a man who would,

if occasion arose, gamble with the destinies of empires. People thought of him as he appeared when he sat in the witness chair before the South African Commission. He was questioned as to the Jameson Raid, the whole world waiting with tense anxiety for his answers. Munching his sandwiches in the box, he appeared unutterably bored. From time to time he lifted his tankard to his lips and, on setting it down, drawled out something that added nothing, and less than nothing, to the information of the Commissioners. He looked as stolid and as immovable as the rock of Gibraltar. But all this, Sir Henry Lucy assures us, was purely a pose. Sir Henry knew Rhodes intimately. "There were tears in his eyes one morning," he says, "when he told me that his butler had been suddenly attacked by hemorrhage" and the man for whose word nations waited, spared himself neither trouble nor expense in getting his sick servant away to the healing and invigorating air of the hills.

On the afternoon of March 26, 1902, Sir Lewis Mitchell, his biographer, sat beside Rhodes' deathbed. The patient, he says, was restless and uneasy. Once he murmured: "So little done; so much to do!" and then, Mitchell adds, "after a pause, I heard him singing softly to himself, maybe a few bars of an air that he had once sung at his mother's knee"; and, within an hour, he was gone. In inaugurating the magnificent monument on the Matopos, the work of earth's most eminent sculptors, Earl Grey described Rhodes as a statesman of exalted and noble aims who sought to substitute justice, freedom, and peace for barbarism and oppression in Africa. "The verdict of history," he added, "will pronounce Cecil Rhodes a thinker and builder who, of all his compeers, was the most

powerful force for good in the 19th century." Since then his colossal personality and superlative achievements have grown upon the imagination and appreciation of mankind; yet the centenary celebrations are unlikely to elicit a loftier note of eulogy than is contained in Earl Grey's calm but glowing panegyric.

A LITERARY TRANSPARENCY

He was an English writer of such crystal purity that he stands with Bunyan in a class apart. For Mark Rutherford, like his illustrious predecessor, was the soul of simplicity. He hated fuss, formality, and fame. He concealed his personality behind a pen-name. In that picturesque Sussex countryside in which so much of his sheltered life was spent, there were scores of intelligent and educated people who had no idea that the Mr. William Hale White whom they met every day smoking his quiet pipe on the village green or along the lane, was the Mark Rutherford whose delightful contributions were the chief attractions of their magazines and whose books were rapidly rising to the rank of English classics.

Living in a dreamy, old-fashioned cottage at Groombridge, one of the most charming and idyllic spots in the south of England, he breathed every day the fragrance of the hops, the clover, the new mown hay, and the primrosed woods. He could seldom be enticed to social functions, and rarely, if ever appeared in public. Perfect felicity was his only so long as he was permitted to enjoy his seclusion undisturbed. When the prying world did

contrive to catch a glimpse of him, it was startled. A ruddy, robust, almost sailor-like man, he contrasted so strikingly with the impression that he had given of himself in his books.

All History Incarnate in the Individual

As he lived, so he wrote. There is not a stilted or highfalutin' phrase in any of his volumes. He pruned each sentence with pitiless severity until it said, with diaphanous clarity, exactly what he wished it to say—nothing more and nothing less. He argued that, since the thing he was writing was true, he dared not hamper the truth by elaborate and ambiguous terminology. The path of a cannonball, he said, is straight in exact proportion to its velocity. His novels stand unique in literature. They are so guileless and so artlessly developed that you scarcely realize, as you lay one down, that you have been reading a novel at all. It is like a draught of cold water to a parched tongue. One whose palate is accustomed to highly effervescent beverages may miss the sparkle and the tang; but they will be surprised to find their new fancy so satisfying and refreshing. In Mark Rutherford the plot is never a roaring torrent, surging through narrow channels and tumbling over precipitous falls; it is like the gentle trout-streams of his own secluded countryside, smooth, winding, graceful, and flowing with consummate ease. The things of which he writes are simple things; the scenes simple scenes; the people simple people.

He exalted this idea to the level of a philosophy of life. In his *Revolution in Tanner's Lane* he argues that the inner experience of the most commonplace boy or girl is a cross-section of the history of the universe. In every

village and hamlet, he maintains, you may find, if you have eyes to see it, the Garden of Eden, the murder of Cain, the Deluge, the salvation of Noah, the exodus from Egypt, the epic of David and Bathsheba with the murder of Uriah, the Assyrian invasion, the Incarnation, the Atonement, and the Resurrection, to say nothing of the Decline and Fall of the Roman Empire, the Inquisition in Spain, the Revolt in the Netherlands and the French Revolution. To Mark Rutherford each separate human represents all humanity in a cameo.

Artificiality the Enemy of Beauty

One of his earliest works is entitled *Births, Deaths, and Marriages.* It is suggested by the fact that he was for some time a clerk at Somerset House. "And there, in Somerset House," he says, "lies the real history of the English people. My life's epochs are my birth, my marriage, and the memorable days when Tom and Jack, Susan and Jane came into the world and gathered around me. The history of the nation may be in Hume or Macaulay, but the history of the people is in the Registrar-General's vaults at Somerset House." In every one of his novels he strikes the same note. He pooh-poohs pomps and pageants: he glorifies men and women. In one of his books he tells of a little servant girl whose mistress had bought a new hat a day or two earlier. "Lor, miss," the girl exclaims, "you haven't looked at your hat today!" "No, Mary," the lady replies, "why should I? I didn't want to go out." "Oh, how can you, miss?" answers the maid, "why I get mine out and look at it every night!" Mary, Mark Rutherford explains, was happy for a whole fortnight with a happiness cheap at a very high price.

Such innocent joys were the light of Mark Rutherford's eyes. Confronted by the glare of public life, he blinked like an owl dragged from the darkness of its hollow tree into the broad glare of noon. Parliamentary practices completely baffled him. He could never see how honest men could storm at each other across the floor of the House and then walk off to dinner arm in arm!

Everybody knows the lovely story of the way in which Theodore Watts-Dunton, the novelist and literary critic, pitied the frailties of Algernon Swinburne—lonely, deaf, miserable, and tormented by an incurable malady—and took him into his own home at Putney. The two little old men one day conceived a fancy to meet Mark Rutherford and invited him to "The Pines." "Do you read the new novels?" asked Watts-Dunton of his guest. "No," replied Mark Rutherford, "I am getting to be an old man: I read my Bible!" "Ah," responded Watts-Dunton, "that's exactly what I do!" In that temper he serenely ended his days. Just before he died he wrote to *The Times* to protest against the artificial ornamentation of the London parks. "We do not want Paris or Versailles," he insisted, "but a place of which we can say that it is just like being in the country." This was Mark Rutherford, delightfully natural, utterly unaffected, as genuine as a man could be. Literature and life are both the better for a few such men who, saying exactly what they think, think exactly what they say.

A MASTER OF MEN

When, more than a hundred years ago, the outbreak of the Maori War was causing widespread apprehension throughout the civilized world, nobody played a more courageous or more creditable part than the youthful Bishop Selwyn. In his *Links in My Life,* Commander J. W. Gambier of the British Navy, tells how he met Selwyn in New Zealand in those perilous and difficult days, and he affirms that, beyond a shadow of a doubt, the wisdom and firmness of the young bishop saved the entire white population from massacre at the hands of the infuriated Maoris.

Selwyn was only 32 at the time of his appointment to the see. A new spirit was abroad. It was decided to imperialize the Church. Bishops were to be appointed to evangelize the remotest dependencies of Empire. New Zealand was chosen for the first experiment, and Selwyn was selected as the man. In addition to outstanding gifts of mind and heart, he was a famous athlete. He had rowed in the Oxford-Cambridge university boat race. When he became curate at Windsor, he ventured to visit a certain thoroughfare that enjoyed a particularly unsavory reputation. A towering giant intercepted him, and, adopting a pugilistic attitude,

ordered the clergyman to leave the district. With a skillful blow, Selwyn sent the bully sprawling, and was thereafter treated in the neighborhood with the most profound respect.

The Man for a Difficult Moment

Selwyn's physical fitness stood him in excellent stead in the distinguished career that followed. Only a man of muscle could undertake the herculean task that awaited him under the Southern Cross. In the nature of the case, much of his Maoriland journeying had to be done on foot. The world has seldom seen such adventurous pilgrimages. He negotiated the most broken and forbidding country with a facility that would have kindled the envy of an engineer. "He was a man of most fascinating and dominating personality," Commander Gambier assures us. "He was a born leader of men. The Maoris adored him and he held them in the palm of his strong hands." The best authorities agree that any dire calamity might have overtaken the infant colony at that critical juncture had it not been for Selwyn's wise, strong, and persuasive statesmanship.

When things were at their worst, and the nerves of all parties were cruelly frayed, the bishop would ask the angry chiefs to meet him. Taking his life in his hand, he would ride to the appointed rendezvous. It was, Gambier says, a truly terrifying spectacle. The frowning chiefs were surrounded by hordes of absolutely naked savages, their eyeballs starting from their sockets, their teeth gnashing and sweat pouring from their dusky bodies, while the rhythmic stamp of their feet seemed to shake the very ground. They brandished bloodthirsty weapons, and, above

the roar of their hoarse guttural grunts, could be heard the shrill, fiendish screams of their fanatical priests urging them to still more violent exhibitions of fury. But Selwyn confronted them without the slightest manifestation of fear, and, twisting them round his fingers, assuaged their passions and brought them to reason.

Making the Best Use of a Bad Blunder

His energy was inexhaustible. One would have thought that a country like New Zealand, a thousand miles long, would have been big enough to satisfy the consecrated ambition of any reasonable person. But it was not big enough for Selwyn. In drawing up the Letters Patent of his antipodean see, the crown solicitors had made an astounding and egregious blunder. The area under the young bishop's authority should have been defined as lying between latitudes 34 S. and 50 S. But, by an incredible slip, an "N" was substituted for the first "S." Selwyn noticed the mistake, chuckled inwardly, but said nothing. He saw that the error would make him bishop of the entire Pacific! Later on, when the turmoil in New Zealand brought his work there almost to a standstill, he set out in a schooner of his own to Christianize all these coral reefs and cannibal islands. He recognized, of course, that it would be absurd to attempt missionary work, in the ordinary way among these countless groups. It would take years to acquire the languages, master the customs and overcome the prejudices of the islanders. He determined to resort to strategy. Visiting the various archipelagos, he took a boy from this island and a boy from that one; he persuaded them to accompany him to New Zealand; and then he

bent all his energies to their evangelization and education. Afterwards, he returned each of these neophytes to his native land to spread among his own people the gracious influence of his transfigured life.

And while the bishop was lost to sight amid the multitudinous islands of the South Seas, the leaven that he had hidden in the national life of the Maori people was silently but surely working. During the later phases of the Maori War, for example, Gen. Cameron and his men were encamped on the banks of the Waikato. The troops were almost destitute of provisions. The Maoris held a very strong position at Meri-Meri, farther up the river, and an attack was expected at any moment. Suddenly, several large canoes were seen coming round the bend of the stream, and Col. Austin went down to reconnoiter. To his surprise he discovered that, instead of being crowded with fierce and tattooed warriors, the canoes were loaded with milch goats and potatoes! The British officers stared in abject amazement. "We heard," explained the Maoris "that you hungered. The Book says: 'If thine enemy hunger, feed him!' You are our enemies: We feed you: that is all!" And the canoes put off on their return journey to Meri-Meri as though nothing extraordinary had happened. Dr. Selwyn remained in New Zealand until 1867 when, at Queen Victoria's strong personal request, he accepted the historic see of Lichfield where, in a place of great honor in the cathedral, his monument and grave are still to be seen.

A MASTER OF ROMANCE

C harles Reade was the youngest child in a family of 11. By the time he appeared on the scene his parents were a trifle tired of the troublesome business of rearing their offspring, with the result that his upbringing was largely entrusted to mentors and preceptors. For some time Charles was confided to the tender mercies of the Rev. Mr. Slattery, of Iffley, who, according to many accounts, might easily have been the original of Mr. Wackford Squeers. Reade's one fond memory of his boyhood was the memory of his mother. To her, he insisted, he owed almost everything. It was while equipping himself at Oxford for a legal career that he made up his mind to devote himself to literature, and quarter of a century later he published *The Cloister and the Hearth*, which was not only his masterpiece but destined to take its place as one of the priceless classics of English literature.

Why was it that the hand that was capable of penning so glorious a work gave us nothing else worthy of comparison with it? The sweet, sad love story of Gerard Eliasson and Margaret Brandt stands peerless among the productions of Charles Reade. The rest of his works

pale into insignificance beside it. The explanation is that *The Cloister and the Hearth* represents its author's escape from a calamitous infatuation. Charles Reade mistook his calling. To the day of his death he hugged to himself the illusion that he was a heaven-born dramatist. He gave implicit instructions that he was to be described upon his tombstone as a dramatist and novelist, putting the dramatist first. He firmly believed that he was a dramatist by inspiration and a novelist by accident. This unfortunate obsession hampered all his efforts. Some of his novels were first written as plays and were only transmogrified into novels because of failure before the footlights.

Mismanaged Thrills and Sensations

The procedure has obvious drawbacks. It is not easy to produce fiction of delicate artistry out of the second-hand materials of a discarded drama. It is as if a man tried to make a beehive out of an old dog-kennel. It may prove a tolerable and even serviceable beehive, but there will always be something of the dog-kennel about it. As soon as a man has resolved to make, not a dog-kennel but a beehive, he should set himself to make the beehive as little like a dog-kennel as possible. The one huge blemish on the work of Charles Reade is that he proceeded on a diametrically opposite principle. Having made up his mind to write, not plays but novels, he made his novels as much like plays as he possibly could. He exhausts all his energy on the thrills, the sensations, the exciting situations. He is never happy unless a lunatic asylum is in flames, a ship sinking or a bridegroom being foiled at the very altar. He makes you feel that the pages that intervene between these purple patches, are to him, weary wildernesses of arid sand.

With those commonplace paragraphs he has no patience. He often gives you the impression that, knowing what is coming—the highway robbery, the discovery of the vital document, the loss of the nugget or the explosion in the hold—he is in a fever of breathless anxiety to tell you all about it. He is literally sizzling with the tremendous secret. Sometimes his evident perturbation defeats its own ends and you suspect, from his manner, the approaching surprise. Mr. Christie Murray poked fun at Charles Reade's penchant for hurling his sensations at his readers in capital letters. He is so wildly agitated that ordinary type seems a ridiculously feeble vehicle for the conveyance of such an astounding denouement, and he therefore prints in glaring capitals the sentence that, he expects, will take your breath away. But the perverse reader, finding his eye arrested by the huge capitals a page or two ahead of him, reads the too-conspicuous words in advance and is thus deprived of the hair-raising experience that the author had so carefully prepared for his delectation.

A Great and Stately Human

Happily Charles Reade gave us one book so different from the others that it seems to have come from another hand. It is a combination of superb imagination and finished scholarship. The man who has read *The Cloister and the Hearth,* carries in his mind forever afterwards, not a blazing building, a wayside murder or the sensational discovery of buried treasure, but the entire panorama of the variegated life of medieval Europe. To peruse it is, as Sir A. Conan Doyle once said, like going through the Middle Ages with a dark lantern. When, 80 years ago, it first made its appearance, its failure seemed assured. It was published as

a serial. The Editor grew sick and tired of it before the tale was half told; his candid criticism angered the author and the narrative was discontinued, leaving the climax of the novel to the imagination of the reader.

On reflection Reade himself was inclined to accept that harsh judgment as final, and thought seriously of tossing the immense manuscript into the flames. Even after it had been for some years published he pointed out with evident sadness that, for one person who had read *The Cloister and the Hearth,* a hundred had read *It is Never Too Late to Mend.* The crucible of time has, however, vindicated the merit of which the general recognition was so tardy and it is on the work that his contemporaries least esteemed that Reade bases his claim to immortality. He was a great human. Gigantic in stature and massive in build, he was vigorous and athletic. The Liverpool cricket ground still cherishes the record of a hectic innings in which he mercilessly punished one of England's best-known bowlers. Best of all, he genuinely loved his fellowmen. Most of his books were written to abolish the disfigurements and to sweeten the amenities of social life, and, in recognition of this, his work has awakened the gratitude and even excited the affection of all his readers.

A PEER OF EVERY REALM

On March 28, the day on which he was laid in his honored tomb at Westminster Abbey, the mind turns instinctively to Sir Isaac Newton. It is 250 years since, at the height of his great renown, Isaac Newton was called to the presidency of the Royal Society and honored with his knighthood. Any tribute to such a man must of necessity be couched in superlatives. Is there any department of human life that has not been incalculably enriched by his restless mind, tireless researches, and ceaseless industry? Is there any man to whom our civilization owes more?

It is not merely that he discovered much, invented much, and suggested much: but, in addition to all his direct personal triumphs and achievements, he created an atmosphere, and set forces in motion, that made possible the reaffirmations and revolutions that stand associated with hundreds of other illustrious names. He was the architect, they were the builders.

The birth of Newton is synonymous with the birth of British science. Before Newton's time, Green points out in his *Short History of the English People,* only two discoveries of real value had been produced by British thinkers; Gilbert's discovery of terrestrial magnetism at the close of

Elizabeth's reign, and Harvey's discovery of the circulation of the blood in the reign of James. Until Newton's time the people of England had been much more deeply immersed in the excitements of politics and of war than in the pursuit of science. But, during Newton's lifetime, science made up for lost time and a hurricane of enlightenment set in. Nor was the eminence of Newton the eminence of a hillock that rises from a flat and barren desert. Living in an age of intellectual giants, he dwarfed them all. It was a period of furious and fruitful thought.

The Sunrise Glistens on Many Peaks

An age of triumphs dawned. The Greenwich observatory was established; Halley made his famous discoveries in relation to the fluctuations of the tides; Hooke revealed to men the boundless possibilities of the microscope; Boyle inaugurated a new era in experimental chemistry; Wilkins revolutionized the study of philology; Sydenham changed the entire spirit of medical scholarship; Willis startled men by his investigations concerning the structure of the brain; Woodward founded the art of mineralogy; John Ray raised zoology to the rank of a science; and modern botany sprang into existence. Here was a dazzling galaxy of glittering splendor!

Yet, as Green says, great as these names undoubtedly are, they are lost in the luster of one other name—the peerless name of Isaac Newton. In the resplendent firmament upon which the men of that time gazed in wondering admiration, his star, indisputably the brightest, made all the others seem strangely pale.

Outstanding among his claims upon our veneration stands the almost incredible versatility of his brilliance.

A courtier and a knight, princes and princesses delighted in his society, and no visitor to the palace was ever more welcome than was he. A philosopher and a theologian, he wrote books on such abstruse subjects as *The Mysteries in the Prophecies of Daniel,* and *The Apocalyptic Visions of the Book of Revelation.* In discussing such nebulous themes he could hold his own with the most scholarly divines of his time. A member of Parliament, he interested himself in all the social and national questions of the day. As Warden of the Mint, he juggled skillfully with the complicated problems of high finance. As Professor of Mathematics at Cambridge University, he invested his Chair with a distinction and an authority it had never previously known.

And all these exacting activities he regarded in the nature of casual sidelines or fortuitous occupations, bearing but a remote relationship to those complex and sublime scientific investigations to which the most transcendent powers of his mighty intellect were bent.

Tardy Recognition of an Innate Genius

Newton's amazing achievement cannot be credited to the advantages of youthful opportunities or vocational training. His father dying before he himself was born, his mother took to herself a second husband; and amid the vicissitudes of this domestic dislocation, Isaac's upbringing became a somewhat haphazard affair. Living in the country, it was taken for granted that the life of the boy would be spent on the land. That being so, a very limited and very ordinary education would, his relatives argued, meet all the needs of the case. To make matters worse, the awkward-looking lad was himself afflicted by a pronounced inferiority complex, the thraldom of which was broken in the strangest

possible way. Circumstances beyond his control forced him to fight one of the bigger boys at the school. To Isaac's own astonishment, he soundly thrashed his burly opponent.

From that moment he began to suspect that there must, after all, be something in him and he resolved to develop and exploit his powers. Impressed by the boy's new attitude to life, his family, who had arranged to send him to work at the age of 14 suddenly decided to give his intellectual powers ampler scope. They extended his schooldays and even whispered to one another concerning the possibilities of a university.

Sensing the more inspiring atmosphere, the boy's mind responded astonishingly. He surprised his tutors by his aptitude for mechanical and mathematical problems. The most trivial incident awoke his curiosity and set him thinking. Everybody knows Voltaire's story of the way in which the falling of an apple in an orchard set Newton hot-foot on the scent of the law of gravitation. In the year that witnessed the Great Fire of London, he, a youth of 24, amused himself by taking a ray of light to pieces.

His hungry mind probed all the mysteries of form, weight, and color. He plunged into the intricacies of hydrostatics and hydrodynamics and laid down the principles by which the infinitudes of the seas could be more safely navigated. Turning his attention to comets, planets, and the irregular orbs, he wrested from the skies the secrets that they had held for ages in their clutch. Indeed, it is doubtful if there remained one single branch of scientific inquiry to which he did not apply his penetrating genius. Yet, with beautiful modesty, he used to say that he felt like a little child gathering shells on the shore while the immensities of the ocean stretched out before him.

A PRINCE OF JOURNALISTS

The outstanding fact about Daniel Defoe is, not that he wrote *Robinson Crusoe,* but that, preeminently a journalist, he presented the British people with their first real newspaper. Long before that time there had, of course, been papers of a kind. But they were feeble ventures, lacking practically all the qualities that go to make a modern journal. Everything was crude, clumsy, inartistic, yet it was the best of which the journalism of that day was capable. Then, all at once, Defoe set his wits to work and changed everything. It occurred to him that a newspaper might very well contain, not only the news, but illuminating comments on current happenings, together with articles that would furnish intelligent and valuable guidance on important public questions. He therefore launched his famous *Review,* and, with its appearance, the history of modern journalism really began.

It was altogether in harmony with the adventurous and romantic tenor of Defoe's life that he was actually in prison when he established his celebrated journal. Such an enterprise was, in those days, a thankless task. Public opinion was a thing of fits and starts. A new sovereign

ascended the throne, or a new government came into power, and, hey presto! the whole country changed its coat. The heroes of one day became the villains of the next, and, contrariwise, men passed at a bound from pillories to pedestals. The consequence was that, for years, Defoe was as much in prison as out of it. Indeed, the only authoritative personal description that we have of him is embodied in an advertisement offering a reward for his apprehension. Hunted and harried, his business went to pieces: his wife and family were denied all intercourse and communication with him: and, for a while, he was dead to all the world. Yet there were compensations.

When the Body Languishes the Soul Soars

As Milton's blindness enabled him to peer into ghostly realms that he had never previously explored, so, as in Bunyan's case, the incarceration of Defoe's body proved the emancipation of his mind. He brooded in solitude, and it was in the course of that silent and reflective process that the idea of his *Review* occurred to him. It was in prison, too, that he first conceived of *Robinson Crusoe*. It was essentially a journalist's conception. Our literature is fairly rich in tales of shipwreck; yet no such story ever written has seriously challenged the supremacy of Defoe's masterpiece. And, when we ask ourselves for an explanation of his peerless achievement, we are startled by the discovery that while others, as novelists, have written of life on a desert island, Defoe approached the same task in the spirit of the journalist.

In all other romances of maritime adventure, we pass from one set of sensational circumstances to another. In

Robinson Crusoe we have no such exciting transitions. There is scarcely one page in the book that can be called thrilling. Even the shipwreck itself is not dramatically depicted. "Why," asks Dr. A. Compton Rickett, in his *History of English Literature,* "why do boys take *Robinson Crusoe* so warmly to their hearts? It is because, in a journalistic way, Defoe is always giving us the small details; he tells us the very things that a boy is curious to know. He explains how many biscuits Crusoe ate, how he built his raft, and what the parrot talked about." Just once, in the episode of the footprint on the sand, he perpetuates a denouement of the kind so dear to the hearts of such thrill-makers as Charles Reade. For one brief and hectic moment Defoe became a real full-blooded novelist; but he seems ashamed of the lapse, hangs his head in contrition and never attempted anything of the kind again.

Robinson Crusoe as a Philosophy of Life

In the most extraordinary way Defoe combines the romantically imaginative and the severely prosaic. Whether he is giving us history or fiction matters little: he gives it to us as a journalist would give it. We know exactly how his characters dressed, how they talked, what they ate and how they spent their money. Nothing is too trivial; nothing too matter of fact. In a word, Defoe is a journalist to the fingertips; and, although his influence on modern journalism is seldom recognized, his work in that connection is more notable and more enduring than that of any person of any age. Added to all this stands the fact that *Robinson Crusoe* is a great religious classic. Unfortunately the abbreviated popular editions omit the passages that

Defoe himself regarded as vital. In the book as Defoe wrote it, the more serious aspects of life loom large: and nobody can read the narrative without being touched by Crusoe's vivid delineation of his spiritual pilgrimage. The record is all the more impressive when we reflect that, in his original preface to the third part of the book, Defoe explains that the deeper experiences of his hero are in reality a reflection of his own: that portion of the narrative is to be regarded as autobiographical.

Robinson Crusoe is a tonic for lonely souls. It is designed to show that, in the last analysis, the human soul is a terribly solitary affair. Robinson Crusoe's most sensational discovery on the island was his discovery of God. Defoe said in prose what Whittier sang in verse:

> I have not been where islands lift
> Their fronded palms in air;
> I only know I cannot drift
> Beyond His love and care.

Defoe lies, in company with John Bunyan, the younger Cromwell, William Blake, Isaac Watts, Thomas Goodwin, John Owen, the mother of the Wesleys and a host of other notabilities, in the old burying place at Bunhill Fields, in the very heart of the city of London. And over his grassy grave the schoolboys of England, with their pocket money, have erected a stately obelisk, which, together with the work that particularly excited their admiration and gratitude, will keep his memory green for many generations to come.

A PROSAIC POET

Robert Southey was not in the accepted sense, a genius. Saul may be among the prophets but certainly Southey never was. He displays little or nothing in the way of inspiration. He never sparkles, never glitters, never astonishes us by superb flashes of brilliance. He does not scintillate. He was essentially a plodder. He totted terribly, and every line that he penned betrays something of the effort it cost him.

To men who rely upon their poetic fluency, Southey stands as an everlasting rebuke. He was a paragon of industry. His music is not the music of the bird that sings because it cannot be silent; it is the music of the finished vocalist who has practiced their solo with such persistence that they are themselves almost sick of it.

He lacked the instinct and the temperament of a poet. His mind was never at rest. He allowed himself no leisure. He never learned to dream. He spent all his time accumulating mountains of facts and amassing enormous hoards of useful information.

His library was one of the largest in the land, and the hours that he spent in exploiting its wealth represent

the great bulk of his lifetime. He was eternally hunting up something or correcting something or verifying something. Such pursuits are all very well in the scientist, the biographer, or the historian; but they do not facilitate the spiritual evolution of the poet.

No Ear for Nature's Finer Vibrations

Strangely enough, although Southey lived within working distance of the most exquisite beauty spots of the English Lake country, he gives no evidence of real communion with the more intimate vibrations of Nature.

Unlike his friend, Wordsworth, he never penetrated the subtle secrets that woods and waters were waiting to whisper in his ear. A primrose by the river's brim, a yellow primrose was to him, and it was nothing more. To Wordsworth, Nature was a temple and he was its priest. Southey knew nothing of that sublime mysticism; he missed the best without even knowing that he missed it. That being so, he can never, despite all his claims upon our gratitude, be regarded as one of our really classic singers.

Turning to his prose he wrote a waggonload of books that are best forgotten. His biographies alone survive. His *Life of Cowper* is good; his *Life of Wesley* is so fine that Coleridge says that he could read it when he could read nothing else; and his *Life of Nelson,* by far the best of them all, stands as a model of all that a biography should be.

In his own proper person, however, Southey provides us with a study far more attractive than either his poetry or his prose. The frantic struggles and amusing misfortunes of his youth read like a chapter of some grotesque romance. He would be a clergyman! But no; that would require a

certain amount of theological certitude; and he possessed none! He would be a doctor! But no; the dissecting room and the operating theater would induce nausea! He would be a lawyer! But no; the thought of the dusty statutes made him yawn! So he abandoned himself to literature and hoped for the best.

Personality Superior to Prose or Poetry

His later life, crowded with sorrows, is nevertheless pervaded by an irresistible charm. His boy died; his wife lost her reason; and he himself outlived his memory. But, to the last, he haunted his huge library, staring blankly at the shelves and affectionately stroking the books whose contents he could no longer recall.

Generous to a fault, he once placed his entire wealth at the disposal of an unfortunate friend. His companions— men like Wordsworth, Coleridge and Lamb—loved him devotedly, and reveled in his society. When Coleridge's family was left uncared for, Southey added the children to his own household. His letters to these youngsters are among the choicest things that he ever penned. It was for them that he wrote the well-known story of *The Three Bears*. Solemn as a judge among his compeers, he could keep a group of children rocking with merriment.

In his *Four Georges* Thackeray expresses the fervent hope that the brave and beautiful life history of Robert Southey will never be forgotten. It is, he says, sublime in its simplicity, its energy, its honor, and its affection. Thackeray extolls the sweetness and the grace of Southey's private and domestic life as one of the real adornments of a sinister and dissolute age.

In the presence of such tributes, we easily forgive, and as easily forget, the drab mediocrity of much of the work that his hectic pen produced, and treasure together with his wiser and weightier outpourings, the memory of the man.

A SAGA OF SCHOOL LIFE

It was the proud distinction of Thomas Hughes that he enshrined the prosaic annals of a great school in a fragrant atmosphere of classical romance. Close to the railings of the Art Museum at Rugby a fine white marble statue perpetuates his fame. Many boys from Rugby have served the Empire and the world with rare brilliance and effect; but Thomas Hughes, by writing *Tom Brown's Schooldays,* has surpassed them all in his glorification of the school and in imparting to its halls a deathless renown. "It is the jolliest tale ever written," Kingsley assured Hughes, many years after its publication; "isn't it a comfort to your old bones to have been the author of such a book?" It certainly was; and to the end of his days, Mr. Justice Hughes was fond of telling of the way in which the inspiration came to him.

He was 33 at the time. His youth and early manhood had been dominated by the spirit of the famous school and of its illustrious headmaster, Dr. Thomas Arnold. It is not too much to say that, just as the history of the world divides itself into two parts—BC and AD—so the history of the

public schools of England divides itself into two sections—before Arnold and after. The distinguished doctor died in 1842, Hughes being then in his teens. Stanley's *Life of Arnold* was published two years later; but although most critics would give it a place among the six finest biographies in the language, Hughes felt, as most of Arnold's old boys felt, that it did not quite convey to the ordinary reader a vivid and realistic impression of the Rugby atmosphere. The thing struck these youthful admirers of Arnold as a trifle stolid and statuesque, if not actually stodgy.

Literary Genius Kindled by Personal Devotion

Hughes said as much one Summer's evening in 1856 in the course of a conversation with John Malcolm Ludlow, the intimate friend of Kingsley. Hughes and Ludlow were both barristers and were sharing a house at Wimbledon. "I have often thought," ejaculated Hughes, "that good might be done by a real novel for boys, not stiff and pedantic like *Sandford and Merton* but written in a light-hearted and rollicking spirit and aiming only at being interesting." Encouraged by his companion's wholehearted and enthusiastic concurrence, Hughes confessed that he had already set his hand to something of the kind, but, he added with a wry face, he was sure that it was not worth publishing. Brushing aside the young author's modesty, Ludlow insisted on being shown the manuscript, and, a few nights later, Hughes placed it, with many a protest and many an apology, in his friend's hand.

Ludlow was electrified. "I soon found," he says, "that I was reading a literary work of absorbing interest which would place its author in the very front rank of living

writers." For a day or two Ludlow could scarcely lay down the engrossing folios. "Tom," he exclaimed, when at length he reached the end, "this must certainly be published! It will be good for you; it will be good for Rugby, it will be good for the whole world." Hughes gradually became infected by his friend's confidence. "I always told you," he wrote to Alexander Macmillan, publisher, "I always told you that I would write a book that would make your fortune, and, surely enough, I have actually done it! I've been and gone and written a one-volume novel for boys. It concerns Rugby in Arnold's time." Hughes meant the note as a frivolous and frothy little joke; but it proved prophetic. Macmillans were then in a very modest way; they had but a small shop at Cambridge; but the popularity of *Tom Brown's Schooldays* set them on their feet and they were soon enjoying an established position among the foremost publishing houses of London. In 20 years the book romped through 65 editions.

To Understand Boys is to Master & Mold Them

Every boy who has read *Tom Brown's Schooldays*—and what boy has not?—has come more or less directly under the influence of Arnold. With Tom Brown, he has seen the illustrious dominie on the cricket ground, in the lanes round Rugby, in the classroom, and, above all, in the familiar chapel that Arnold has made famous for all time. For the secret of Arnold's amazing success was that he thoroughly understood boys. He knew that a boy has ways of his own, ideas of his own, sensations of his own, and, by the same token, a religion of his own. Arnold never attempted to make religion conventional or stereotyped;

but he made it sane, robust and irresistibly attractive. For, as the novelist says, the great event in Tom's life, as in the life of every Rugby boy of that day, was the first sermon from the doctor. We all seem to have seen the oak pulpit standing out by itself above the school seats; the tall, gallant form of its admired and revered occupant; and his kindling eye as he warmed to his congenial and absorbing theme. "And who that had once heard it," asks Hughes, "could ever lose the echoes of the voice, now soft as the low notes of a flute, now clear and stirring as the call of the light infantry bugle, of him who stood there week by week?" Those accents haunted the ears of the boys till their last sun set.

Hughes tellingly describes, too, the long lines of fresh young faces, rising tier above tier down the whole length of the chapel, from that of the little boy who had just left his mother to that of the young man who was about to plunge into the big and busy world. "It was," he says, "a great and solemn sight, and never more so than at that time of year when the only lights were in the pulpit, and the soft twilight stole over the rest of the chapel, deepening into darkness in the high gallery behind the organ." Tom's visit to the doctor's tomb represents one of the most affecting and inspiring scenes in our literature. Indeed, the whole book is quite extraordinary. It is remarkable, not only as a convincing and lively story of school-life that has appealed to every subsequent generation of schoolboys, but as the most eloquent tribute to a noble and knightly personality that has ever been contributed to the stately library of English fiction.

A SINGER IN REVOLT

The anniversary of the death, in 1909, of Algernon Charles Swinburne revives the memory of a state of things that was very familiar to Londoners half a century ago. The scene is easily reconstructed. The great reading room at the British Museum is wrapped in its traditional quiet. The only perceptible sounds are the rustling of the papers, the soft footfall of visitors, and the solemn ticking of the clock. Suddenly, however, the swing door opens and there enter two odd little figures, one of whom horrifies the occupants of the spacious apartment by addressing the other at the top of his loud and raucous voice.

This noisy little nuisance who, being stone deaf, is blissfully ignorant of the enormity of his transgression is Algernon Charles Swinburne, the poet. He is a thin, narrow-chested creature with sloping shoulders and a head slightly reminiscent of Shakespeare, a head that is altogether out of proportion to his diminutive body.

He is grotesquely attired in a disreputable coat, with his trousers so absurdly braced that a generous expanse of white sock intervenes between the extremities of his nether garments and the tops of his boots. The singularity of his

appearance is in keeping with his character as a rebel. For Swinburne's entire life and work represent a fierce and relentless revolt.

From the cradle to the grave he was at war with the scheme of things in which he found himself involved. He snapped his fingers at tradition; shook his fist in the face of society; and, like a schoolboy kicking his way through a litter of Autumn leaves, he trampled ruthlessly on all the literary codes and standards that his predecessors had established.

Catching the Spirit of the Ocean

As a small boy at Eton he raised the flag of rebellion, and one of his verses hints ruefully at the painful consequences:

> Alas for those who at nine o'clock
> Seek the room of disgraceful doom
> To smart like fun on the flogging block.

In that youthful experience his whole life is reflected as in a cameo. Through all his days Swinburne scorned convention, and, by way of castigation, he writhed under the ostracism and condemnation of an outraged world. Both heredity and environment fed the fires of insurrection in his soul. The son of an admiral, he was reared beside the sea. The wild waters are apt to infect men with their own intractability. Lamartine declares that those who spend their lives within sight of the ocean unconsciously imbibe its restless and unconquerable temper. Swinburne certainly did.

He has told us how the shrieking winds and the turbulent waves molded the spirit of his childhood. Amid the storm and confusion of the elements, he reveled in the thunder that drowned his voice, in the tumultuous blasts

that threw him off his balance, and in the hurricane of flying foam that stung his face and blinded his eyes. He loved to hurl himself into the raging surf and to feel himself hurled about by it in return. It thrilled him with a furious luxury of poignant exuberance and electrified his every nerve.

From such stormy scenes he can block with his ears full of music and his eyes full of dreams. The sea awoke within him the spirit of defiance. In everything that he wrote, and in all that he did, one seems conscious of the influence upon him of those racing and foaming breakers with which he fought and flirted as a boy. They explain him.

Chesterton affirms that, if ever there was an inspired poet, Swinburne was that man. In some respects he attains super-excellence. For stately and majestic diction he is unsurpassable. Many of his most characteristic phrases are arrayed in dazzling splendor, like kings on their way to coronation. Possessing an extraordinary flair for the intrinsic beauty of words, Swinburne revealed the art of a great composer in harmonizing and dovetailing rich and tuneful sounds in such a way as to produce the most metrical and lyrical effects. There is an orchestral grandeur about his faultless lines. He was, as Tennyson finely said, a reed through which all things blow into music.

A Serene Sunset Follows a Stormy Day

Like all men, he had his faults. He yielded at times to outbreaks of the most frightful temper, a blemish that disgusted and alienated some of his staunchest and most distinguished friends. As long as their tolerance could endure the strain that his petulance and irascibility imposed upon it, he lived with George Meredith and Gabriel Rosetti at Chelsea. Among his

intimates were numbered Burn-Jones, Holman Hunt, John Ruskin, James Whistler, Monckton Milnes, Savage Landor, and Guiseppe Mazzini. They made allowance for his terrible epilepsy and his maddening deafness, and, overlooking his fiery outbursts, saw only the best in him.

When Swinburne was 42—unmarried, tormented by his ill-health, horribly miserable, and prone to seek comfort in alcoholic excess—Theodore Watts-Dunton, the novelist and literary critic, took him into his own home. And there, for 30 years, the two lived together— "the little old genius and his little old acolyte in their little old villa at Putney." In that riverside suburb, Swinburne became a very familiar figure. He was to be seen every day walking by himself, his deafness rendering companionship embarrassing. He noticed nothing and nobody. He was lost in a dream world of apocalyptic vision and glowing inspiration.

Little by little, Mr. Watts-Dunton weaned him from his bondage to his brandy bottle. Towards the end his acerbity grew less pronounced and a certain subtle sweetness occasionally marked his behavior towards those about him. And, when in 1909, he suddenly died, it was found that he had left all that he possessed to the understanding and sympathetic benefactor who, with beautiful unselfishness, had sheltered his infirmities and solaced his solitude for so long.

A STAINED SPLENDOR

In the very first conversation between Scott and Lockhart—afterwards Sir Walter's son-in-law and biographer—the two men talked of the majestic beauty of Goethe's countenance. It was, Lockhart declared, the noblest by far that he had ever seen. The extraordinary magnetism that was destined to enchain half of Europe, early asserted itself. It bound the boy's mother, hand and foot. She was only a girl when he came into her life. She worshiped him and he knew it. He painted pictures of exceptional beauty and gave the first indications of his real genius by inventing fairy tales of rare delicacy and charm for the amusement and edification of that young mother of his. "There I sat," writes that lady, in recalling those halcyon days, "and Wolfgang held me with his large dark eyes; and when the fate of one of his favorites was not according to his taste, I saw the angry veins swell on his temples and watched him as, with a brave struggle, he restrained his tears." It is a pretty picture and must be set over against some scenes in his life story that are less attractive.

The boy was only nine when, for the first time, he attended a theater, fell under the influence of Shakespeare

and recognized the possibilities of the dramatic art. Nothing would do but that he himself should write a play or two. He did so, without achieving any startling success. But, in the process, it became whispered among his youthful companions that Wolfgang could write poetry. Eager young swains engaged him to write love songs in praise of their ladies; bridal couples paid him handsomely to celebrate their nuptials in glowing verse; and desolated mourners coaxed him into penning elegant panegyrics to their dear departed. It may be that the breathing of this sentimental atmosphere prematurely developed his own romantic propensities. At any rate, he was only 14 when he became involved in his first serious love affair.

A Nation Impatiently Awaits a Poet

It happened that Goethe began to produce poetry at the identical moment at which Germany was casting about for a laureate worthy of coronation. At the age of 21 Goethe had published *Goetz von Berlichingen* and *Leiden des Werther*. What more could any nation desire? Clearly the Fatherland had produced a prodigy able to rank with the French Voltaire and the English Johnson! Karl August, a lad of 18, who had recently succeeded to the throne of Saxe-Weimar, commanded the proud young poet to visit his palace. A halo was thus placed upon his brows. He was given an official position at court. The country was ringing with his fame. At the age of 26 he found it necessary to travel incognito to evade the embarrassing attentions of the crowds. This, be it noted, was in 1775. Johnson was then 66 and Voltaire 81. Johnson smiled ponderously; Voltaire sardonically; but Germany felt that it could afford to

ignore their disdain. Happily, Goethe's premature corona-
tion affected neither his genius nor his ambition; for, while
his countrymen were raving over his apprentice efforts,
he himself was calmly pondering the scheme of *Faust*.
Never was a monumental work more deliberately execut-
ed. He conceived the idea as a youth; he published the first
part at the age of 57; he completed the entire poem a few
days before his death at the age of 82.

Carlyle struggled bravely to make a hero and a saint
of Goethe. In point of fact, Goethe was neither, and, in his
heart of hearts, Carlyle knew it. The knowledge hampered
him. When the sage sat at his desk writing *On Heroes and
Hero-worship*, and came, in due course, to his chapter on
"The Hero as Man of Letters," his fingers itched to set
down the name of Goethe as the typical literary hero. He
had written hundreds of pages about Goethe; was, indeed,
never tired of the theme. But Goethe as hero! Goethe as
saint!

Depression Generated by a Poet's Despair

In his *Life of Goethe,* Abraham Howard confesses that,
at times, his subject taxes all his powers of endurance.
He shudders at the way in which, as a boy, Goethe tore
flowers and birds to pieces in order to dissect them, and
as a man, tore women's hearts to pieces in order to study
their emotions. Yet it has to be recognized that, judging
him by his best work, Goethe stands without a rival, or
finds a rival in Shakespeare alone. *Faust*, his masterpiece,
probably is the greatest poem of the 19th century. As
a work of art, it is simply peerless; it approximates as
closely to perfection as any man need wish. It is the one

production in which Goethe strikes a note of stark sincerity. "It is," as one of his commentators points out, "a reflex of the struggles of his own soul. Experience had taught him the vanity of philosophy; experience had taught him to detect the corruption underlying the veneer of civilization; and *Faust* is his wail of despair over the emptiness of life." The conclusion is, of course, depressing, but everything about Goethe is depressing.

Mr. Gladstone would not admit that either the man or his writings had a single virtue. We need not be as severe as that. G. E. Lewis devoted the best years of his life to the study of Goethe. Yet, with all his admiration, he sternly rebukes those who would rank Goethe with Shakespeare. Goethe thought Shakespeare sublime, and, if he had foreseen that men would one day compare his own work with that of the English bard, he would have prayed most fervently to be saved from the rash zeal of such uninstructed friends. Dr. J. A. Hutton, just before his death, visited Frankfurt. In a street that had been bombed to atoms, he found a little heap of dust and rubble. It appeared to have been raked together by pious hands, for, on the top of it, was a piece of board bearing a card. And on the card was scrawled: "This was the birthplace of Goethe!" There is something exquisitely symbolic, as well as poignantly pathetic, about that heap of ruins.

A WARTIME SINGER

William Wordsworth was born on the seventh of April. His personality was for all the world like a dazzlingly brilliant gem in a strangely battered and unsightly casket. His forbidding exterior largely explains the blindness of his contemporaries to his inestimable worth. They simply gave him the cold shoulder. It never seems to have occurred to the literary pontiffs of that wealthy period that the gaunt and unattractive figure with stooping shoulders, shambling gait and downcast countenance, haunted the picturesque shores of the English lakes was the natural successor of Chaucer, Shakespeare, and Milton.

Dorothy, his sister, alone recognized the hidden preciousness that lurked in this shapeless lump of dross. Woman-like, she was in ceaseless distress about his unimpressive contemptible appearance. She was so accustomed to walking by her brother's side that it shocked her when circumstances compelled her to walk behind him. Now and again visitors—a lady and gentleman, perhaps—came to Grasmere. It fell to her lot to attend the lady while her brother strolled on ahead with the gentleman. "Is it possible?" she would ask herself on such occasions, "can that be William? How very mean he looks!" And De Quincey, in telling the story, agrees that she had ample ground for shame. Such a man could not

court the smiles of London society. He was only at home in wandering among the rhododendrons on the banks of Rydal Water, or, under the shadow of Nab Scar, declaiming at the top of his voice the latest stanzas that his genius had evolved. Snapping his fingers at ducal drawing-rooms, he paid the inevitable penalty. He snubbed society and society shut him out.

Singing His Blithest Songs while Cannon Roared

He had, however, a message, and he had the artistry to deliver it. He was the prophet of a dramatic age. The terrible and long-drawn-out conflict, which ended with the complete overthrow of Napoleon at Waterloo, lasted with scarcely a break from 1793 to 1815. Those were the identical years during which Wordsworth was writing. In the year of the war he published his first poem; in the year of Wellington's final triumph at Waterloo, Wordsworth gave *The Excursion* to the nation. The analogy is intensely significant. For it reveals the striking fact that a generation almost wholly absorbed in the momentous issues that hung upon the fleets that grappled at Trafalgar, upon the armies that fought at Waterloo, found something singularly satisfying in the poetry of Wordsworth. Yet Wordsworth was not singing battle songs. He was "the high priest of a Worship of which Nature was the idol."

Wordsworth was more subdued than any of his brilliant contemporaries, but his stillness was the hush that one experiences in treading the aisles of a stately cathedral. The universe is to him a temple; he himself is a white-robed priest serving its hallowed altars. The reverent quietness of the eternal broods over him. He finds in everything, as Dr. Compton Ricketts puts it, a central peace subsisting at the

heart of endless agitation. This it was that moved a generation sick of strife to turn its face so wistfully towards him.

> From Shelley's dazzling glow or thunderous haze,
> From Byron's tempest-anger, tempest-mirth,
> Men turned to thee and found—not blast and blaze
> Tumult of tottering heavens—but peace on earth,
> Nor peace that grows by Lethe, scentless flower.
> There in white languors to decline and cease;
> But peace whose names are also rapture, power,
> Clear sights and love; for these are parts of peace.

The Healing and Tonic Value of Noble Verse

Wordsworth's interpretation of Nature was not so much an exposition of Nature herself as the revelation of something that he had himself discovered lurking behind Nature. "I have learned," he says, "to look on Nature not as the hour of thoughtless youth," but, he adds: I

> I have felt
> A presence that disturbs me with the joy
> Of elevated thoughts: a sense sublime
> Of something far more deeply interfused,
> Whose dwelling is the light of setting suns,
> And the round ocean, and the living air,
> And the blue sky, and in the mind of man;
> A motion and a spirit that impels
> All thinking things, all objects of all thought,
> And rolls through all things.

As a young fellow Matthew Arnold often met Wordsworth at Grasmere and found it difficult to excuse the

crudities and oddities that grated painfully upon his own cultured and academic temperament. But such idiosyncrasies could not blind him to the priceless value of Wordsworth's minstrelsy. Time, he wrote,

> Time may restore us in his course
> Goethe's sage mind and Byron's force;
> But where will Europe's later hour
> Again find Wordsworth's healing power?

Wordsworth's healing power! It is a pearl-like phrase and is as true as it is beautiful. It reminds us of Sir William Watson's fine apostrophe. Speaking of Wordsworth, he says that "he gives to weary feet the gift of rest." The exquisite expression is fortified by many concrete testimonies. John Stuart Mill has told us in his autobiography that, in the crisis of his life, Wordsworth acted upon him like a medicine. And more recently, Lord Baldwin has confessed that, on laying down the cares of office after twenty years of incessant strain, he could at first read nothing. Then he turned to Wordsworth's *Excursion* and afterwards to the *Prelude*. "This," he says "braced my mind and did me untold good." This all goes to show that Lord Morley was right when he affirmed that it is the peculiar prerogative of Wordsworth to assuage, to reconcile, to fortify. This is the Wordsworth who must live forever. With a pitying smile the generations forget the uncouth face, the awkward gait, and the garb. But, forgetting these easily forgettable things, men will remember the lofty notes that, in an age that sorely needed them, the poet so sublimely struck. And, remembering what is so well worth remembering, they will weave grateful garlands of amaranth about the laureate's honored name.

AN AUSTRALIAN EPIC

No name in our annals shines with a richer luster than Matthew Flinders. He stands as a brave Homeric figure against the empty skyline of a newly-discovered continent. As Prof. Ernest Scott has eloquently pointed out, there never was, until Flinders applied himself to the task, any deliberately planned, systematic, persistent exploration of any portion of the Australian coast. "The continent," Prof. Scott says, "grew on the map of the world gradually, slowly, almost accidentally. It emerged out of the unknown, like some vast mythical monster heaving its large shoulders, dank and dripping, from the unfathomable sea and was metamorphosed by a kiss from the lips of knowledge into a being fair to look upon and rich in kindly favors." It was Flinders who laid his vigorous and practical hand upon the misty and nebulous realm that was just emerging from primeval chaos. He transformed it into an actual geographical quantity and gave it status and recognition. Indeed it was he who, brushing aside the old unsatisfactory designation of New Holland, gave to the new continent a name, inscribing the word Australia in bold capitals across the map of the world.

In Tasmania particularly, the name of Flinders deserves to be held in deathless honor. The story of the hazardous voyage in the course of which Flinders and his friend Bass sailed round this island has taken its place among the stateliest epics of the sea. But our obligations neither begin nor end with that classic adventure, for it was largely owing to the glowing description of Tasmanian products and possibilities which Flinders published in England that Capt. Collins was sent here and the settlement of Hobart first established. Moreover, one of the first monuments to Matthew Flinders in Australia was erected by Sir John Franklin when that illustrious navigator was Governor of Tasmania.

Earth's Greatest Discoverers Pay Heaviest Price

It is with a start of surprise that we recall the fact that the intrepid and dauntless navigator whose audacity and erudition enabled him accurately to survey our interminable Australian coastline, and to present to the old world the first reliable maps and records of Australian territories, was only 40 years of age at the time of his death; and that, even then, six of the last years of his life were spent as a French prisoner at Mauritius. The story of his voyage in the Tom Thumb, a tiny vessel only eight feet in length, will probably be told and retold as long as a love for tales of adventure holds its place in the hearts of men. He sailed for thousands of miles along our Australian coasts in a crazy old craft in which today men would scarcely risk their lives on the most tranquil rivers. Provided only that a vessel could be coaxed to float, however dilapidated it might be, it was good enough for Flinders. The Investigator, the ship which

he eventually commanded, had to be abandoned at Sydney as rotten and utterly incapable of repair; and finally, after suffering shipwreck in the Porpoise, he undertook, in the teeth of everybody's advice, to attempt to reach England in the Cumberland, a vessel that every sailor expected to founder or to fall to pieces as soon as she got well out to sea.

At Mauritius he was captured by the French, who were then making frantic efforts to obtain recognition for themselves as the real discoverers of Australia, and who were extremely anxious that the revelations of Flinders should be obscured or delayed until their own book had been published. Suspecting some design of this kind, the astute Flinders had, however, taken the precaution to send a duplicate set of his invaluable documents to England by another vessel, and the nefarious schemes of the wily Frenchmen were thus ignominiously frustrated. And, after enduring six years of totally undeserved incarceration, Flinders hurried to England, wrote his book and died on the very day on which it saw the light.

Reputation that Emerged from Cloud to Sunshine

The imposing annals of Australian exploration are tinged with pathos at every turn. The moving story of Burke and Wills, the great overlanders, is rivaled in this respect by the touching record of Flinders and Bass, the great navigators. Those deaths in the dusty desert are no more dismal than the deaths of those two heroic sailors who first placed this island on the atlas. Bass simply vanished: it is supposed that he was captured by Spaniards and done to death in the silver mines of South America. Flinders fell

into the clutches of unscrupulous Frenchmen, in whose merciless hands his iron constitution was shattered and his valuable life hurried to a premature close. It seems to be the melancholy fate of some of the world's best workers to be consistently denied the recognition that their eminent services so obviously merit. This lamentable misfortune certainly dogged the steps of Flinders.

After his death, an application was made for a pension for his widow, the case of Capt. Cook being cited as a precedent. But, although the King viewed the project with favor, the Prime Minister (Lord Melbourne) contrived to compass its defeat. Flinders was treated by Britain pretty much as Columbus was treated by Spain. In their *History of Australia,* the Sutherlands speak of Flinders as our greatest maritime discoverer. He was they say, a man who worked because his heart was in his work; who sought no reward and obtained none; who lived laboriously and rendered honorable service to mankind: yet who died, like his friend Bass, almost unknown to those of his own day, but leaving a name which the world is every year more and more disposed to cherish. In the records of Australian pioneering, Flinders has seldom been accorded the place to which his unselfish and astonishing exploits entitle him. But as Australia assumes her place in history and the romance of her past is investigated and extolled, the gallant deeds of Matthew Flinders will be recited with increasing pride and his name will be mentioned with deepening reverence and resounding acclaim.

ARCADY AND BABYLON

The little village of Fairford, in Gloucestershire, likes to celebrate year by year, the anniversary of the death of one of the most striking and attractive personalities in English history. The story of John Keble is an epic of self-effacement. The men of the Nineteenth Century experienced few greater astonishments than that which came to them when, in 1823, Keble gravely announced that he was leaving Oxford, the scene of his academic triumphs, in order to return, as his father's curate, to the little Gloucestershire village in which he had been born. His amazing renunciation seemed to lack both rhyme and reason. At that moment he had the world at his feet. The stars in their courses seemed to have fought in his favor. First as student, and then as professor, he had covered himself with glory and won the most coveted prizes of university life.

But at the age of 31 he took the decision that fell like a bombshell among the classic halls of the university. "It seemed incredible," as Dean Church exclaimed, "that the most distinguished scholar and teacher of his day, honored and envied by everyone, should retire from Oxford at the

very height of his fame in order to busy himself with a few hundreds of Gloucestershire peasants in a miserable curacy!" Nobody could make head or tail of it. It simply did not make sense. Yet John Keble knew what he was doing. The fact is he was worried about the world. It seemed to him, as he looked out upon it from the cloistral stillness in which he so delighted, that the people of England were steeped in the lethargy of a deadly indifference to all high issues, while the Church was engrossed in fierce and bitter controversies. What could he do to mend matters? It would, he felt, be useless for him to fulminate against the evils of his time; such a course would only add to the babel of discordant voices.

A Brilliant Mind Gives Countryside a Voice

In this dilemma the spirit of his boyhood swept back upon him. In those days he had nourished his inner life on the quietude and charm of the countryside. The fragrance of the clover, the silver purity of the brook, the sweetness of the hedgerows, the sparkle of the dew-drenched meadows, and the song of the thrushes in the copse had woven themselves into the very fabric of his being. If only he could recapture the tranquillity of that sylvan loveliness and by some magic means pour it into the fevered minds of his quarrelsome fellow-countrymen! If, instead of criticising, attacking, and denouncing the qualities that grieved and shocked him, he could administer, as a potent antidote, the condensed essence of all that was purest and best in the leafy lanes of England! If only he could breathe the perfumes of Arcady into the stifling highways of Babylon! He makes up his mind to try.

And here he is, back in Fairford, about to put his theory to the test. He cuts a striking figure. His fine eyes

are full of playfulness, intelligence, and deep feeling. His unaffected simplicity, genuine humility, engaging innocence, and utter unworldliness are written unmistakably upon his countenance. And yet, though a twinkle haunts his eye and a smile seems to be playing perpetually about his lips, there is deep gravity in his expression and even an element of sadness. For he is still thinking about the agitated world he has left behind him, and is wondering how he can heal its hurt. The problem solved itself more easily than he could have supposed. As he crossed and recrossed the village green at Fairford, and moved up and down those quiet country roads, he meditated on the themes that, in the course of the Church's calendar, would demand his attention on each approaching Sunday. A born poet, his secret thoughts found natural articulation in tuneful verse, and as soon as he reached the rectory he would pencil down the poems that had imparted an added delight to his woodland stroll.

Songs Soothed and Strengthened a Nation

His manuscripts grew in number until he had a poem for each day of the Church's year. His friends, hearing whispers of this hidden hoard, insisted on seeing it. Among these was Thomas Arnold, afterwards the famous headmaster of Rugby. "Why, Keble," he exclaimed, "these poems are unparalleled: nothing like them exists!" Thus extolled, a new idea seized Keble's mind. Perhaps this bundle of manuscripts represented the concrete realization of his nebulous dream! Perhaps it was through this channel that he was to pour into the troubled life of his country the strength of her hills and the peace of her valleys! In response to the pressure of his friends he agreed to publish the verses, so long as no name

was attached to them. The volume met with unprecedented success. The fact that, during Keble's lifetime, nearly 200 editions were demanded proved that, in *The Christian Year,* he had hit upon the remedy that the world so sadly needed. He says of his poems that

> ... their cherished haunt hath been
> By streamlet, violet bank, and orchard green,
> 'Mid lonely views and scenes of common earth.

He aims, he says, to soothe the minds of men, and beyond the shadow of a doubt he did it.

There are few things in our literature more touching than the way in which, after 30 years of perfect wedded life, John Keble and his wife set out together on life's last journey. They lay on their death-beds in adjacent rooms. He was wheeled within sight of her, and they gave each other, by way of farewell, a fond but silent glance and a feeble wave of the hand. When he passed she called the family round her own bed to give thanks that he had been spared the sorrow of surviving her. And then, shortly after, she rejoined him. In one of the choicest recesses of Westminster Abbey, close to the Unknown Warrior's Tomb, the visitor may find his monument. Around it are those of Charles Kingsley, George Herbert, William Cowper, William Wordsworth, and Matthew and Thomas Arnold. In that exquisite spot, and in that congenial company, he seems very much at home, and it is pleasant, in that atmosphere, to take an affectionate and respectful leave of him.

AUTUMN LEAVES

There must be few persons who have not been more or less deeply impressed, in recent years, by the emphatic and almost painful detachment of the seasons. They go their way and leave us to go ours. They do not meddle with our affairs, they brook no interference on our part with theirs. Come war or peace, gladness or grief, Spring bursts in vernal freshness from the barrenness of Winter, and Autumn follows somberly on the golden riot of Summer. The same feeling haunts us, in a more vague and nebulous way, as we mark the risings and settings of the sun, the waxings and wanings of the moon, the ebbings and flowings of the tide, and the formation, night after night, of the starry constellations. But suns and stars do not affect us quite as the seasons do. Those celestial bodies are infinitely remote. We know very little about them, and there are few points of sympathy between them and ourselves.

But the seasons are near at hand. They give tone and character to the experiences of every day. They enter directly and intimately into our lives and yet, with a disregard that appears contemptuous, they behave as though they had no interest in us. With all the empires of the earth staggering in unprecedented convulsion, the birds have sung their mating songs in the Springtime as though no drop of blood were

being shed, and the leaves have taken on their dapple tints in Autumn as though things were as they have always been. With Spring and Summer and Autumn and Winter, it is business-as-usual, age in and age out. During the American Civil War, Whittier was impressed by the same thought—

> So, calm and patient, Nature keeps her ancient
> promise well
> Though o'er her bloom and greenness sweeps the
> battle-breath of hell.
> Ah, eyes may well be full of tears and hearts with
> hate are hot;
> But even-paced come round the years and Nature
> changes not.

Whittier argues that Nature's tranquillity is based on her clearer view of the good that will be born of so much suffering, and the thought was never more grateful than is at this hour.

Is Autumn Depressing or Invigorating?

Of Autumn all this is particularly true. No season has been so much misunderstood and so persistently misinterpreted. The minstrels who have undertaken to sing the songs of Autumn have almost invariably set their songs in a minor key. Autumn, they have told us, is the twilight of the year; Autumn is sunset; Autumn is decline, decrepitude; Autumn is the season at which things make haste to die. The literature of Autumn is steeped in the bleakest pessimism. To this general rule there are, of course, notable exceptions. Miss Wilhelmina Stitch is one of them. In Autumn Miss Stitch sees nothing depressing. The lines in which she celebrates

the splendors of Autumn stand out against the misereres and jeremiads of the more pretentious bards as a brilliant rocket stands out against the darkness of a pitch-black night. Her song stirs the blood like a trumpet blast that immediately follows a dirge—

> Oh for a caravan right now! That I may travel at my ease
> And stare at every flaming bough, drink in the beauty of the trees.
> The Springtime's dainty pink and white can rouse a gentle ecstasy,
> But Autumn's colors, flashing bright, they make a vagabond of me!

It is part of the peculiarity of Autumn that she rushes upon us somewhat abruptly. None of the other seasons appears so suddenly. In one of his inimitable word paintings, Richard Jefferies points out that it is almost possible to record the precise day on which Autumn makes her appearance. There are, it is true, one or two premonitory signs of her approach. The leaves of the lime begin to fade, tell-tale spots of lemon color bespangle the silver birch, and a suspicious tinge of yellow sweeps across the fern. But all at once a more decided change mantles the whole horizon. As though beneath a wizard's wand, the hedgerows become bronze and russet and purple and saffron, the birds in the copses become ominously silent, the grasshoppers vanish from banks and from meadows, and the furze on the moorland sparkles in the morning with the dew-drenched webs of innumerable spiders. All this breaks upon us suddenly, telling us that Summer is a thing of yesterday.

Nature Braced for a New Adventure

Nature in Autumn reminds us of nothing so much as of the excited child who, delighted that their antics have given the beholders pleasure, instantly proceeds to repeat the performance. Proud of her golden harvests and her luscious fruitage, the earth makes up her mind to do the whole thing over again and she proceeds to gather up all her powers for the prodigious undertaking. Penelope sets to work at this season of the year to unravel her wondrous web, taking to pieces in the Autumn the dainty tapestries and delicate embroideries that she wove with such deft fingers in the Spring. The flutter of the leaf to the ground and the return of the sap to the root are essential items in this beneficent program. The leaves fall off because the new and tender buds are already in formation. They vanish so that the blustering winds may lose their power over the budding branches, and the frail yet mighty potentialities that slumber in those bare boughs are thus saved from gusty violence.

The rustle of Autumn leaves announces, therefore, not a dead end, but a new beginning. Autumn is aglow with promise and radiant with hope. By every richly-tinted leaf she tells of a better day dawning. If her last harvest was poor she will now endeavor to atone; if it was good, she will attempt a still more splendid achievement. Those who have looked into the face of Autumn and thought her gloomy have woefully misunderstood her. There is in those rustling leaves a whisper of exultation and confidence. Those who attune their ears to her secret melody will detect in it an assurance that, good as may have been the past, the best is yet to be.

BRILLIANCE AND CHARM

On the twenty-fourth of March, 1920, the world was impoverished by the death of a very gifted and very gracious lady. It was on the eleventh of June, nearly a century ago, that, in the modest settlement then known as Hobart Town, a little girl was born who was destined to be described from the historic pulpit of St. Paul's Cathedral, London, as "perhaps the greatest Englishwoman of our time." The words, uttered by the celebrated Dean Inge, are worth recalling today. Not on personal grounds alone, but because it forges a link between ourselves and a stately British tradition, Tasmania is proud of the fact that Mrs. Humphry Ward was born in this island State. Herself a distinguished novelist, Mrs. Ward was the grand-daughter of Thomas Arnold, the famous headmaster of Rugby and the niece of Matthew Arnold, whose essays and whose poems were regarded as the ultimate articulation of 19th century culture. Her father was appointed an Inspector of Schools in Tasmania.

No novelist in our history has divided the critics into hostile camps as sharply as has Mrs. Ward. Professor W. N. I. Phelps, of Yale University, refused point blank to recognize Mrs. Ward as a novelist. She never wrote a novel

in her life, he bluntly declares. He recalls a Sunday evening in 1894, when, on finishing *Marcella*, he felt as if his mouth were full of ashes. By way of damning the lady with faint praise, the professor benignly admits that Mrs. Ward is a serious, earnest, thoughtful, and deeply-read woman with a passion for improving the world and everybody in it. He dismisses her masterpiece by observing, as though between the puffs of his cigar, that she once wrote a treatise on religious reform and called it *Robert Elsmere*. Could any diatribe be more caustic? As against this, however, Benjamin Jowett, the omniscient master of Baliol, wrote to tell her that *Robert Elsmere* was the best novel since George Eliot.

Intense Culture Wedded to Lofty Passion

On one and the self-same day two of the great London dailies reviewed *Robert Elsmere*. The one declared that, at last, *Adam Bede* must take second place among the first-class novels written by feminine hands; the other said that the new book was an unutterable dreariness, a sandy desert of weary words, an insufferable boredom, an iniquitous waste of time, temper, and material. "Were ever such contradictory judgments?" the young authoress demanded of her publishers. She could make nothing of it. But, since the critics insisted on instituting a comparison between George Eliot and herself, she drew some crumbs of consolation from the records of the similar conflict that divided the literary pontiffs when *Daniel Deronda* first saw the light.

We probably make the closest approximation to the truth when we aver that Mrs. Ward was a penetrating rather

than a popular novelist. Like George Eliot, her fiction is introspective romance. She lays the soul bare. She is instinctively an analyst, a scientist, a philosopher. She seems to be in the secrets of her characters. She scrutinizes their motives, their sensations, their passions; she tells the tale from the inside. Others wrote from the circumference; she wrote from the center. "Her strength lies," as Mr. Gladstone once told her, "in an extraordinary wealth of diction never separated from thought; in a close and searching faculty of social observation; in generous appreciation of what is morally good; in the sense of a mission with which the writer is possessed; and, above all, in the earnestness and persistency of purpose with which that mission is pursued through every page." Mr. Gladstone held that the value of Mrs. Ward's work lies in its profound influence upon the thoughtful few rather than in its capacity to appeal to the multitudes who glory in a rural idyll, or who devour with avidity the alternating thrills of a sentimental and exciting romance.

Loftiest Truth Incapable of Demonstration

Not that Mrs. Ward's work was destitute of sentiment. On the contrary, she was, in a very real sense, the apostle of the sentimental. Living in an age in which everything was being analyzed in the intellectual dissecting room and tested in the scientific crucible, Mrs. Ward's outstanding contention was that the monumental verities of the Christian faith, while necessarily incapable of logical demonstration, nevertheless make to human hearts an irresistible appeal. Readers of *Robert Elsmere* will never forget the poignancy of the emotions with which they

witnessed the terrible scene when Robert, having stated his abstract and academic doubts to his simple-hearted and bewildered wife, stuns her by announcing his intention of leaving the ministry. Mrs. Ward held that life is a matter of notions and of emotions, and that, while notions have their value, emotions also possess theirs.

She had her reward. Thousands of people who were feeling tired of the frothy and saccharine fiction of the moment, bought and discussed *Robert Elsmere, David Grieve, Marcella,* and the other novels. For some years she enjoyed an enormous vogue, and, in consequence, a princely income. The soul of generosity, she spent as rapidly as she acquired. Miss J. T. Stoddart says that no writer since Sir Walter Scott practiced such lavish hospitality. Until just before she died, she entertained at her beautiful home at Grosvenor Place the most eminent men and women in the world. It broke her heart when failing health compelled her to leave it. She stood with moist eyes in the great entrance hall on her last night there and seemed to see, moving hither and thither, the shades of Burne-Jones, Stopford Brooke, Henry James, Lowell, Martineau, Roosevelt, Northbrook, Goschen, and all her honored guests. But her work, into which she had poured her very self, had exhausted her strength. She died in 1920, bequeathing to the world the memory of a good and great woman who, cherishing the loftiest ideals, had immeasurably enriched the world by living a singularly beautiful life and creating a literature that perfectly matched it.

COURT AND COUNTRYSIDE

The villagers of Bemerton in Wiltshire never forget to commemorate on the third of April, the birth, in 1593, of George Herbert, whom Coleridge regarded as the purest religious poet of all time. Izaak Walton always felt that the writing of Herbert's biography represented the crowning glory of his own literary career. From the very outset, George Herbert had everything in his favor. Delicately nurtured and liberally educated, he early became a favorite at Court and gained the personal intimacy of the King. James never looked upon the dignified and graceful bearing of the handsome youth, or listened to his deep, rich musical voice, without wishing to have him constantly attached to his royal person. In view of Herbert's mastery of European languages, he made him Public Orator, an office that involved him in the task of drafting His Majesty's personal correspondence with foreign princes and potentates. Hoping that this might lead to his appointment as Secretary of State, George eagerly accepted the post. But, in 1625, King James died and the outlook changed.

For some time before this crisis broke upon him, George had felt less and less satisfied with the kind of life in which his position at Court involved him. His mother, having entreated him to enter the ministry, he retired to a pretty little hamlet in Kent to review the perplexing issues. The longer he pondered the matter, the less inclined he felt to return to the palace. But, before he could make any announcement of his decision, three important developments complicated matters. His mother died; he discovered that he was doomed to a consumptive's grave and with lightning suddenness, he fell in love.

Love at First Sight—and Before

It came about in this way. Eager to fortify his physical frame, he went, in 1629 to spend a long holiday with a relative, the Earl of Danby. Not so far from Lord Danby's house dwelt Mr. Charles Danvers. Meeting George Herbert, Mr. Danvers capitulated unconditionally to his spell. Moreover, he had nine daughters, and he declared that he would be the happiest man living if one these daughters— Jane, his favorite, for preference—could win the heart of Mr. Herbert. The good man sang his new friend's praises in Jane's ears so persistently and persuasively and successfully that, as Izaak Walton says, she fell in love with him without even seeing him. Within three days of their introduction, they were man and wife. The union proved an ideally happy one. No pages of Izaak Walton's biography are more affecting than his narrative of the perfect sympathy and understanding subsisting between these two.

Married in 1629, Herbert died in 1632. Three months after his marriage, the king and the bishops decided

to exercise some pressure in securing his talents for the ministry. He was offered the parish of Bemerton, near Salisbury; Dr. Laud, afterwards Archbishop of Canterbury, told him that it would be a mortal sin to decline; and the matter was soon settled. The story of Herbert's ministry at Bemerton reads like a tender but triumphant idyll. Izaak Walton hesitated before embarking on this section of his narrative, wondering whether it was possible to convey, in black and white, any adequate impression of the facts that he had to recount. Yet, in spite of all his apprehensions, he did it, and did it so skillfully that the Encyclopedia Britannica declares that George Herbert's life at Bemerton, as told by Walton, is one of the most exquisite delineations in biography.

An Idyll of Peace and Poesy

One of his best known poems is entitled "The Odour," a set of rapturous verses glorifying the perfume exhaled by a gracious and unselfish life. Everybody in Bemerton was conscious of the subtle and indefinable fragrance of the young vicar's influence. The cottagers and farm workers worshiped the very ground he trod. Twice every day he conducted services in the little church, ringing the bell with his own hands to call to the sanctuary such of his parishioners as could come. Very few, of course, could attend any one of these numerous services; but it is recorded that "when they heard the bell calling them to pray, they let the ploughs rest for a moment in the furrow while they bowed their heads and mingled their devotions with his." Rich and poor, young and old, felt that in Mr. Herbert, the erstwhile courtier, they had a man who was

equally a master of the visible and invisible worlds, and they treasured his counsel like wisdom distilled from some celestial oracle.

Born when the primroses were beginning to peep through the grass of the hedgerows in 1593, and married when the buds first appeared on the hawthorn in 1629, he died breathing the fragrance of the daffodils and the early violets. His whole life seemed attuned to the beauty and the sweetness of the English Spring. On his last Sunday, he astonished the household by rising and dressing as though he had suddenly returned to health. Seizing his beloved violin, he sang with shining face some of his own choicest stanzas. He handed to Mr. Nicholas Farrer a roll of manuscript. This proved to be the collection of poems, entitled *The Temple*, by which he will always be best remembered. Twenty thousand copies were sold almost immediately. His memorial is to be found in one of the most chaste and charming recesses of Westminster Abbey. Not far from the Unknown Warrior's Tomb is a lovely little chapel commonly known as Little Poets' Corner. It contains a statue of Wordsworth, together with busts of Kingsley, Keble, and the Arnolds—Thomas and Matthew. The dainty chapel is adorned by a noble window dedicated to the memory of George Herbert and William Cowper, two singers who had much in common. In that hallowed spot, and in that congenial company, George Herbert seems very much at home; and it is pleasant, in that atmosphere, to take our leave of him.

ELVES AND PIXIES

The years come and go. We get a new crop of poets, of novelists, of historians, of philosophers, of dramatists and of everything else but; we get no new fairy tales. The supremacy of the old masters is allowed to remain unchallenged. This is the thought that forces itself upon the mind today—the birthday of Hans Andersen. One does not fall in love with Hans Andersen at first sight. He was extremely ugly, painfully clumsy, and poorly educated. His father was a cobbler and the home consisted of but a single room. He himself was never prepossessing. It seems odd that the wizard who filled Europe with fairy palaces and fairy princesses was a singularly prosaic figure—gnarled, sour, and nursing a perpetual grudge. He passed through life with a wry face; his heart was full of self-pity and discontent; he cherished the illusion that he had been abominably treated; and his soul was, as a natural consequence, embittered by the scurvy trick that the fates seemed to have played upon him.

It is curious to reflect that *Andersen's Fairy Tales* was published in the year in which Mark Twain was born. Both men were in revolt against the decrees of fortune.

Mark Twain considered himself a heaven-born philosopher cruelly driven to become a humorist; Hans Andersen regarded himself as a brilliant dramatist doomed by a hard fate to concoct bedtime stories for little children. When first he came to grips with destiny, he found her paths perplexing. A pitiful lameness restricted the ambit of his activity. Conscious of some inspiration, he wrote a novel or two; but the wretched things fizzled out like damp squibs. He composed dramas which were either rejected with scorn or played to derisive or contemptuous houses. At his wits' ends, he shuffled off to seek employment of some more modest kind! He begged to be engaged as an actor in some minor part. The producer looked at his uncomely figure, shrugged his shoulders, and, as a solatium, offered to make him carpenter and handy man. He accepted.

Employed in this unpromising way, he discovered with astonishment that he could captivate the minds of boys and girls by the fireside stories that he told. One of the children to be attracted to his knee was a little girl at Copenhagen who afterwards became Queen Alexandra, the consort of Edward VII.

Fairies are Fairies in Silk or in Sackcloth

It was in 1835 that Hans Andersen resolved to publish a lean little volume of his children's stories. It was an unalluring affair, badly-printed, badly bound and badly produced. Everything was sacrificed to cheapness, for neither the author nor the publisher could imagine that anybody would be willing to pay more than sixpence for stories like "The Tinder Box" and "Little Ida's Flowers"! The critics damned the singular venture with faint praise. The tales

made an appeal, however. People read them, repeated them to their children, and the children excitedly recited to one another. The fantastic characters in the whimsical stories won for themselves a place in the thought and affection of both young and old. The world was a happier place for the pixies and elves that Hans Andersen had set free to flit about it. Had he more such lovely beings stored away in the mysterious recesses of that unattractive head of his?

Responding to such inquiries and snatching greedily at such encouragements, Hans Andersen soon set his wits to work and produced a second volume, and, later on, a third. A year intervened between each of these publications. The profits were, of course, negligible. "In a small fatherland," he wrote, "the poet is always a poor man. Honor, therefore, rather than wealth, becomes the goldfish that he must try to catch. It remains to be seen, whether I shall catch it by telling fairy tales." His heart was still aflame with a fierce rebellion at being reduced to the expedient of inventing these flimsy myths in place of the imposing dramas of which he had formerly dreamed.

Making Possible Today the Flights of Tomorrow

From every point of view he was an oddity. Although his appearance was so grotesque, his mind was an enchanted realm in which any absurd extravagance could flourish. Thus, in spite of the revelation that his mirror daily made to him, he was able to convince himself that he possessed the most amazing charms and that all the loveliest ladies in the land were madly in love with him! With the most perfect composure he could converse with princes as easily as with peasants. Early in life he attracted the attention of

King Frederick VI, and those who saw the two together could detect no suspicion of patronage in the one and no trace of obsequiousness in the other. Hans Andersen could walk and talk with royalty as though he had trodden the corridors of palaces all his life. Yet, forgetting that he had ever moved in such exalted company, he could squat by the hearth of a ploughman or by the brazier of a shepherd, and make himself most perfectly at home in that environment.

The pity is that he never realized the value of his own work. To the last he despised himself for having stooped to it. He forgot that the human imagination is like the old-fashioned pumps. You had to pour water into them before you could draw water out of them. In the same way you must pour something into a child's fancy before its best products will become visible. "Babies," old Dr. Johnson used to say, "Babies do not want your baby talk. They like to be told of giants and castles and of something that can stretch and stimulate their little minds." That was precisely what Hans Andersen did. Assisted by his royal and highly-placed friends, he traveled all over Europe telling his fascinating fantasies to old and young, to rich and poor, to high and low. And, by means of his books, he has been similarly engaged ever since. By quickening the imaginations of millions of children, he has prepared them to play their part in life with greater enjoyment to themselves and with greater profit to mankind. When, 70 years ago today, he died at Copenhagen, he was accorded a public funeral at the expense of the Danish people; and, during the years that have followed, the world has been growingly impressed by the abiding value of his work.

LIFE'S INSURGENT FORCES

Although the meteorologists do not share the popular impression, we commonly think of the wind as being particularly violent at the equinoctial season. To most of us, the wind represents the essence of lawlessness. Rebellious and anarchic, it recognizes no authority but the authority of its own caprice. If, before some august Court having jurisdiction over such matters, the wind were charged with the vandalism and sabotage that we usually ascribe to it, the first thing that would impress the judges would be the fact that, like so many suspicious characters, the accused is known by many names. Some call it the Storm, others the Tempest, while still others refer to it as the Hurricane, the Sirocco, the Tornado, the Gale, the Blizzard, the Simoom; his aliases are legion. But, by whatever name he is called, it is agreed that he wields enormous power and that it is a power ungoverned by principle and untouched by pity. Among the myriad witnesses prepared to bear testimony against him, the four elements—Earth, Air, Sea, and Fire—figure conspicuously.

The Earth complains that the wind uproots her tallest trees and scatters the petals of her fairest flowers. One day he sweeps across the desert, scorching and suffocating any travelers he may happen to find there; and then, when he emerges from those burning sands, and comes upon some more temperate zone, his breath is like the blast of a furnace and everything wilts and shrivels before him. The next day he comes blustering up from the realms of everlasting snow, and people are bitten by the teeth of the blizzard.

The Case for the Prosecution

The second witness, the Air, declares that she is scarcely mistress in her own house. All the world over, she is kept in a state of constant agitation. Even when there come moments of delicious repose, they prove to be but the calm before the storm; and all her tranquillity is soon changed to tumult. The third witness, the Sea, maintains that she suffers most of all. The wind, she avers, lashes her waves into fury, destroying everything and everybody confided to her care. Every shore is littered with the wreckage of brave ships, while the ocean bed is smothered with the hulls of fine vessels and the bones of dauntless people. It matters not to the wind whether the ships are good ships or bad ships. Pirates or pioneers, missionaries or buccaneers; he makes no distinction.

The fourth witness, the Fire, argues that, in a way, she is the worst treated of all. The wind, she alleges, turns all her virtues into vices, her good into evil. If she lights a young child's candle, he blows it out and leaves the little one in peril in the darkness. If she lights a fire at which

some exhausted wayfarer may warm his hands and broil his food, the prisoner blows upon it and sends the flames roaring through the forest, burning down stacks and stables and happy homesteads and spreading ruin and devastation everywhere. She fears, she explains, to start a single genial flame for fear that he will make it the instrument by which he will burn up a prairie or turn a prosperous city into a charred heap of smoldering ashes. Viewing the matter from these four points of view, the case against the wind seems unanswerable. Is there nothing to be said in his defence?

Counsel for the Defence

There is. The wind has a noble record to his credit. In the old days, when ships relied on sails, every mariner knew the horror of being becalmed. To lie motionless day after day on some oily equatorial sea, the water as smooth as glass, supplies running low, and all the activities of life paralyzed! Every captain loathed a windless world. The winds were his friends; he could not move without them. The exploits of Columbus and Cook, Raleigh and Drake, Nelson and Grenville would have been impossible but for the wind. And what of the Trade winds? All writers on maritime affairs dilate on the enormous influence that these stupendous forces, in perpetual and reliable motion, have exercised on the evolution of human history. Scientists, too, eulogize the way in which the heat of the tropics and the rigors of the frigid climes are alike tempered by the kindly activities of the winds; and the naturalists are no less eager to pay their tribute. It is all very well, they say, for us to rail against the storm. The storm may render life at sea uncomfortable or even dangerous. But the wind is

not primarily concerned with sailors. Ships are artificial contrivances that men entrust to the waves at their own risk. The wind thinks, not of ships, but of fish. Frank Buckland, the famous Inspector of Fisheries, says that the stormy seasons are the delight of many of the creatures that live in salt water; the thunder of the breakers is, he says, the grandest music that they ever hear.

Doctors, too, often speak of the cleansing ministry of the winds. They stir up the dust, it is true, and hurl the microbes in our faces. But the broom acts very similarly, and, on the whole, we regard the broom as an implement that makes for cleanliness. It may be that the apparent lawlessness of the wind is part of the camouflage of Nature. In his *Life of Johnson,* Boswell tells of the visit to Lord Melcombe's home of Dr. Young, the author of *Night Thoughts.* One evening the guest had to fight his way back to the house through a terrific storm. "What a night!" exclaimed Lord Melcombe, in welcoming him at the door. "A great night!" replied the doctor, "the Lord is abroad!" It was a poet's way of saying that the wind is not as anarchic or uncontrolled as it sometimes seems. One of the most telling passages in the New Testament reveals the astonishment of a cluster of fishermen on discovering that an authority exists that the winds and the waves recognize and obey.

LORD OF TWO HEMISPHERES

Has England ever produced a poet who, for glowing coloring and vivid imagery, can be compared with Gabriel Charles Rossetti? Like William Blake, who died at just about the time at which Rossetti was born, he was both a great painter and a great poet. It is difficult to say in which department he most excelled. Many men have become masters of one art while dabbling in another. But, as a rule, this secondary application of their skill has been merely a relaxation, a hobby, a sideline. We do not trouble about Michael Angelo's poems or about Dante's paintings. We fasten our attention on Michael Angelo's statues and on Dante's *Divine Comedy*. But, in the case of Gabriel Rossetti, the same principle cannot be applied. Literature and art have each enthroned him.

Tennyson would not have resented a comparison of Rossetti's poems with his own; and Burne-Jones, who enjoyed Rossetti's intimate friendship, was never tired of acknowledging his indebtedness to his brilliant colleague. Nor did Rossetti keep his artistic genius and his poetic genius in watertight compartments. They overflowed freely into each other. There is rhythm and music and harmony

in his paintings; there is life and color and vividness in his poems. Lord David Cecil declared that some of his best poems are on canvas, while some of his best paintings are in verse. As typical of the latter, he instances the stanzas that depict the hushed and dimly-lit room in which a young woman nurses her sick sister.

> Her little work table was spread
> With work to finish. For the glare
> Made by her candle, she had care
> To work some distance from the bed.

To have won so exalted a place in both hemispheres of achievement represents a record of which any man in any age might very well be proud.

Choice Artistry Matched by Fine Personality

Nor are these Rossetti's only claims upon our grateful veneration. He was essentially a personality. The trusted and intimate associate of men like Holman Hunt, John Ruskin, George Meredith, William Morris, Algernon Swinburne, and Hall Caine, he cut a striking figure among the most eminent Victorians. Indeed, his life story possesses all the features of a great romance. As a youth, he was said to be the very image of John Keats. A certain ascetic appearance, which characterized his earlier years, vanished as time went on; he assumed comfortable proportions; became, in actual fact, a trifle stout; but, to the last, his finely chiselled face, his massive forehead, and his clear grey-blue eyes, full of dreamy contemplation and profound penetration, stamped him as a man of the highest culture and refinement.

His career opened and closed dramatically. Perusing, in a magazine, a ballad that powerfully appealed to him, he determined to write to the author, Mr. William Bell Scott, enclosing some of his own verses. Mr. Scott was deeply impressed by the merit of the fragmentary manuscripts, and resolved, when next in London, to call on his enthusiastic young correspondent. To his astonishment, he found him sharing a studio with Holman Hunt. Both painters were engaged upon their first pictures; Rossetti's work seemed to Mr. Scott by far the more arresting of the two. He immediately transferred his wondering admiration from the manuscript that he carried in his pocket to the canvas on the easel before him. From that day, the young painter-poet never looked back, although sometimes the one gift and sometimes the other held the supreme place in his ardor and industry. Men who had won renown in the salons and academies came to his rooms to inspect his pictures; men who had become famous in the literary world loudly applauded his poems.

A Dramatic Burial and Resurrection

The most notable occasion on which one side of his nature waxed while the other waned, was the period that followed the death of his young wife. He married Miss Elizabeth Siddall, a lady of singular sweetness and beauty, whose attractive countenance is reflected in many of the most famous paintings of the time. In the year following their marriage, Rossetti was suddenly bereft of his wife and of their infant child. In a frenzy of grief, he took all his manuscripts and laid them on his dead wife's breast. He vowed that he would never write another line.

How, overtaken by so shattering a blow, could he ever again uplift his voice in song? He was 33 at the time, and for several years, he kept his word. He painted a number of his finest pictures, but the spirit of poesy seemed to have forsaken him. His lyre was mute.

At length, however, time having wrought her immemorial triumph, he shyly penned a few verses whose rich and chastened beauty so affected his friends that they began to think wistfully of the large roll of manuscripts that, for six years, had reposed in Mrs. Rossetti's coffin in Highgate Cemetery. Coaxing him into some sort of reluctant consent, the body was exhumed and the buried poems rescued. On those poems his fame must largely rest, for not long afterwards, his health began to fail, and, after tedious years, in which the tyranny of pain and the confusion of drugs played a conspicuous and melancholy part, he laid aside his laurels and his brush at the early age of 53. With his delicate and fastidious touch, his work is remarkable for its tuneful minstrelsy, its exquisite finish, its gorgeous coloring, and its dazzling imagery. The world has had greater painters and greater poets, but as Lord Leighton once declared, it has never known a man whose work in both sections of his art was marked by such irresistible fascination and such intense sincerity and fervor.

PURITY AND POWER

On March 27, 1889 there passed away one of the most notable public figures of all time. Thousands of people who had little sympathy with his Quaker tenets and his political doctrines, nevertheless admired the Homeric splendor of the personality of John Bright. As we contemplate his burly figure—bold, resolute, almost defiant—and as we gaze upon his leonine head, crowned, during his later and greater years, with billowing hair of snowy whiteness, he appears like the outstanding peak of a sky-piercing range. Everything about him is massive, majestic, mountainous. In her *Records of a Quaker Family,* Mrs. Boyce casually observes that the physical appearance of John Bright stood out in strong and striking contrast against that of most of the young Quakers of his time. The prevailing type, she says, was tall, thin, long-faced, and regular featured. But Bright's robust figure, his strength of chest and limb, his honest face, and resolute carriage reminded one of the stalwart leaders of classical times:

So sturdy Cromwell pushed broad-shouldered on
So burly Luther breasted Babylon.

His life was in keeping with his looks. The heroic achievements of his illustrious career—his gallant fight for the food of the people; his fearless championship of the slave; his stubborn insistence on the enfranchisement of the cottager; his uncompromising stand for civil and religious liberty; his dauntless struggle on behalf of European peace—tower up before the fancy of the student of his life story like the virgin summits of the Himalayas. His character, as Mr. Gladstone feelingly remarked in the House of Commons, is one which we instinctively regard, not merely with admiration, nor even with gratitude, but with reverential contemplation.

Public Service Born of Private Sorrow

The Right Hon. Augustine Birrell always felt that the attitude of John Bright's mind was that of a solitary; he seemed to be brooding on thoughts too fast for utterance. "Deep in his heart," says Trevelyan, his biographer, "there lies always something unseen, something reserved and concealed. Although he was a popular hero, and a man so sociable that he never traveled by train but he drew into conversation his chance carriage companions; and although he was always happy and tender and talkative when wife or child or friend was near, yet the presence of an inner life of deep feeling and meditation could be felt as the moving power of all that he did." All through his long life he impressed everybody as a man with a secret, a secret that gladdened his heart, shone in his face, and imparted color and significance to all his behavior.

He was born at Rochdale in Lancashire. He lived there all his life and sleeps in a modest grave on the lawn on front

of the Friends' Meeting House there. The great day of his life—the day that gave him to the nation and the world—was the day on which his beautiful young wife, to whom he was devotedly attached, was suddenly snatched from him. The story is one of the most tender idylls in the public life of England. It was in 1841. Bright was in his 30th year. The state of the country was desperate. Hungry and miserable, the people were in an ugly mood. Like starving wolves, they were in danger of throwing reason to the winds and pouncing upon anything or anybody that stood in their path. It was the atmosphere in which revolutions are born. And, while the country was in peril, young John Bright, then quite unknown, nursed his private and crushing grief. His friend, Richard Cobden, called upon him. Cobden, seven years his senior, begged the broken-hearted man to turn his eyes from his personal bereavement to the public misery. Why should they not labor together to bring in a better day? Cobden's words rang through Bright's tortured soul like a bugle call. He immediately accepted the challenge. Two years later, he entered Parliament.

Dignity Goes Hand in Hand with Simplicity

In view of the brave record that he has bequeathed to us, it is amusing to reflect that, as a baby, John Bright was so pitifully delicate that he had to be carefully wrapped in cotton wool. His father, as he carried him about the house, often looked at the pinched and puny face of the child, wondering whether he was alive or dead. The poor man never dreamed in those days that his boy would one day stand before the world as the very personification of everything that was sturdy, robust, and virile. Bright

appealed to men of all kinds and classes. No two figures in the public life of their time contrasted with each other, in their outlook upon life, more sharply than John Bright and John Morley. Yet no man admired the titanic strength and crystalline simplicity of Bright more than Morley. Bright, Morley says, was the glory of the House of Commons. He ranks him with Hampden, Selden, and Pym. He regards him as the greatest and most finished orator to whom Parliament ever listened, surpassing even Pitt and Fox. When a whisper ran through the lobbies that "Bright was up!" every seat in the House was quickly filled.

He loved all pure and beautiful things. "He never tired," says Trevelyan, "of mountains and streams or of the sound of Milton and the Bible passages." The last photograph ever taken of him represents him with his arm round his little granddaughter; and the last half-conscious caress of his dying hand rested on the head of his little dog, Fly. Morley confesses that the most pure and impressive piece of religion that he himself ever witnessed was John Bright reading the New Testament to his maidservants shortly after his wife's death, followed by a solemn Quaker silence. He lies, as the last sentence of his biography puts it, not under Gothic arches hung with conquered flags; not among warriors and princes and the statesmen who strove for fame and power; but under the open sky, beside the house of peace where he had worshiped as a child, and within sound of the footsteps of the workmen whom he loved, as they hurry up and down the steep, flagged street. And so he would have wished it.

TEARS AND TWINKLES

It would be a pity to pass the anniversary of the death of Oliver Goldsmith without some fresh attempt to assess his real importance. He stands on a pedestal of his own. Of short but sinewy frame, with low protruding forehead and a round, pale face that is sadly marked with smallpox, he is the most conspicuous figure in that galaxy of half-serious, half-humorous Irishmen—Irishmen who carry a tear in one eye and a twinkle in the other—by whom our literature has been so luxuriously enriched. His welcome into the world was a somewhat doubtful one. His parents were as poor as the proverbial church mice, and their hands were already fairly full. A new baby started a hundred fresh problems. They lived in an Irish village so small, so lonely, and so remote that Macaulay says of it that no settlement in the backwoods of Canada or in the Australian bush could be more difficult of access. Its extreme isolation still further embarrassed the unhappy rector and his wife who were expected to nourish, clothe, and educate their family on a stipend of forty pounds a year.

It is often said that every man is a bundle of contradictions. Goldsmith certainly was. Every vice in

his composition was flatly negatived by a corresponding virtue; every virtue was stultified by a disfiguring vice. As a boy he was brushed aside as impenetrably stupid; yet priceless classics slumbered in his brain. In one sense, no man was more fickle; in another, no man was more constant. As a youth he passed from one occupation to another as though he had no mind of his own. He tried his hand at half a dozen professions in as many years; he was everything by turns, and nothing long. A creature of fits and starts, he was the victim of odd whims and grotesque fancies. Yet in his friendships he was the essence of fidelity. He clung to his companions through thick and thin, and would share his last coin or his last crust with a comrade in distress. In one sense he was a gipsy; in another he was a citizen. In one sense he was positively repulsive; in another he was extremely engaging. In one sense he was the village fool; in another he was a paragon of wisdom. Never, in all probability, was one personality endowed with so many conflicting qualities. Say almost anything you will about Goldsmith, and the exact opposite also is true.

Roll of Waste Paper that Made Literary History

It is part of the pathos of life that the cranks and crochets of a singular man unduly assert and exaggerate themselves, obscuring the nobler and finer qualities which lie beneath. His oddities, his eccentricities, his idiosyncrasies conceal his merit. Among such men, Goldsmith stands out majestically. Small minds were deceived by his ludicrous peculiarities; they recognized in him nothing but a target for their toothless jests. But men of clearer vision and statelier caliber suspected, or discerned, the truth. It is

enough to remember that Edmund Burke, when he heard that Goldsmith was dead, burst into tears; while Sir Joshua Reynolds dropped his brushes, closed his studio, and paced the streets in inconsolable sorrow. And scores of poor creatures, too, illiterate to have read a line that Goldsmith had written, crowded the stair leading to his lodgings and lamented the passing of one who, out of his own poverty, had never refused to help them.

Goldsmith's fame pounced suddenly upon him. One Winter morning towards the end of 1764—he was then thirty-six and had ten more years to live—he was crouching in his garret in desperate straits. His rent being hopelessly in arrear, his landlady had sent for the bailiff. Hearing of the young Irishman's distressful plight, Dr. Johnson lumbered round to see what could be done. "Have you anything," asked Johnson, "on which we could raise a pound or two?" For a while the miserable debtor cudgeled his brains to no purpose. Then, by a sudden brain wave, his erratic mind turned to a roll of manuscript in the corner cupboard, a scroll of which he had thought as just so much waste paper. He told Johnson of its existence. The old doctor shuffled off to a bookseller of his acquaintance and sold the document for sixty pounds. Thus the world became possessed of *The Vicar of Wakefield.*

Goldsmith as Pioneer of Romanticism in Prose

Goldsmith stands today as one of the great formative influences in our literature. Fielding and Richardson pioneered the English novel, but they did not perfect it. They depicted life—life suffused with pathos—but it was Goldsmith who had the genius to perceive that to sentiment

might be added simplicity; it was in him that the idyllic strain first appeared. Goldsmith followed upon the heels of Henry Fielding, and, at the same time, prepared the way for Charles Dickens. And in Dickens and his illustrious contemporaries the school that Goldsmith had founded reached high-water-mark.

Happily for us, Goldsmith has been singularly favored in his biographers. At the outset, it is true, there was ground for the bitterest disappointment. The world will never forgive the men who knew Goldsmith intimately, for having neglected to write the record that, in the nature of things, they were best fitted to pen. Goldsmith had two friends—Johnson and Percy—either of whom would have added materially to his own laurels by inditing the biography. Percy actually undertook to do so. But they both let the opportunity slip. Their failure, however, attracted the attention of a multitude of later writers, with the result that Prior and Forster, Washington Irving and William Black have each in turn presented the world with a vivid and convincing portrayal of Goldsmith's laughable but lovable personality. He who today turns out of the bustle of Fleet St. to explore the quiet gardens and narrow courts that were once haunted by Johnson and Garrick, Reynolds and Gibbon, will stumble as he passes along the north side of Temple Church upon a mound that bears in large letters the name of Oliver Goldsmith. And he will instinctively bare his head in honor of one of the most original, one of the most open-hearted and one of the most ingratiating personages in our literary annals.

THE FIRST GENTLEMAN
IN FICTION

There are four characters in fiction so distinctive and outstanding that we all seem to have seen them. If, at a fancy dress ball, a guest were to masquerade as any one of them, he would be identified at once. The four are Shylock, Robinson Crusoe, Uncle Tom, and Mr. Pickwick. The reflection is suggested by the circumstance that we mark today, the anniversary of Mr. Pickwick's first appearance, an event that his creator celebrated, a few hours later, by getting married. No other book was, to Dickens, quite as notable as *Pickwick*. It was his first serious venture and its success was sweeter to him than that of any of his later triumphs. Mr. Pickwick, who was named after a jolly old innkeeper at Bath, has taken his place among us as the most typical and most celebrated of Englishmen. He is the incarnation of a great national tradition. He represents some of our most amiable qualities. Who would like to think of English literature without him?

Beyond the slightest shadow of doubt, Mr. Pickwick is easily the best known character in fiction. His chubby

face, his prominent glasses, his expansive waistcoat and his short, plump legs are familiar to us all. We seem to have watched him as, standing near the inn door, he expostulates with Sam Weller about the luggage, or as, rising with imperturbable gravity after dinner, he grandiloquently proposes a toast, his right hand waving his spectacles in rhythmic unison with his measured cadences while his left, hidden, behind him, flicks his expressive coat tails by way of additional emphasis. There was a time—one hopes it has not altogether passed—when, if Mr. Pickwick could have appeared in the dingiest court or most squalid alley in London, he would have been instantly recognized by every ragamuffin about the place.

Pouring Personality into Paper

Nobody can read Dickens' first great novel without feeling that, in delineating Mr. Pickwick, the author is thoroughly enjoying himself. His pen seems to romp across the pages. He is describing scenes with which he is himself familiar, and is sketching the sort of people that he has often met. Herein lies the resistless charm and the virile strength of Dickens. In discreetly selecting as the field of his fancy the common ways with which he is so intimate, Dickens secures to himself an inestimable advantage. His imagination roves in a realm that he loves; his toil is always congenial; labor, however strenuous, becomes a luxury. His pages ring with reality.

This is true alike of his pathos and of his humor. Dr. A. W. Ward tells us how intensely real the characters in the books became to their creator. After penning such chapters as those that describe the deaths of Paul Dombey

and Little Nell, Dickens would behave for days like a broken-hearted man who had been bereft of a lovely and favorite child. "He wrote," says Dr. Ward, "with his very life-blood." The same accent of conviction impresses the reader just as much when the writer finds himself in a lighter or a brighter vein. As we devour the drolleries of Pickwick, we feel that Dickens is tremendously enamored of life—real life, every day life, the life of the kitchen, the club, and the street. He was never hampered by a theory; he was consumed with a thirst. "His thirst," as G. K. Chesterton put its, "was for things as humble, as human, as laughable as the daily bread for which we cry to God." And the beauty of it is that he immensely enjoyed everybody in his books; and, as an inevitable consequence, everybody else has enjoyed everybody in those books ever since.

Mr. Pickwick as a National Ideal

Dickens, like all of us, has his faults and his critics have made the most of them. They allege that he is the victim of a constant tendency to gross exaggeration; that, while Shakespeare excelled in his delineations of womanhood, Dickens failed miserably in respect of his feminine characters; that he deals principally with external trappings rather than with basic emotions, giving us the barrister's wig in mistake for the barrister and the beadle's cocked hat instead of the beadle; and so on. However much or however little justice there may be in these indictments, there is no shadow of truth in any of them so far as Mr. Pickwick is concerned. He was a stately, chivalrous, flesh-and-blood reality in the mind of Charles Dickens; he has become a vivid and palpitating reality in the thought of the

Anglo-Saxon world. Indeed, it is extremely difficult to believe that he never enjoyed an actual and corporal existence.

It would be interesting to know how Dickens himself visualised Mr. Pickwick as he bent over his manuscript. Was he tall and thin or short and plump? And how old was he? Few things are more certain than that we owe our conception of the physique of Mr. Pickwick to the artists rather than to the author. Seymour's original drawings depict Mr. Pickwick as lean, gawky, cadaverous. And, as to his age, we are probably inclined to overestimate his years. When asked to slide, Mr. Pickwick explains that he has not done such a thing since he was a boy, 30 years ago. This seems to indicate a man in the early forties. But, after all, these are the merest trivialities; they matter little. The thing that does matter is that, in the person of Mr. Pickwick, Dickens has presented for our contemplation and emulation one of the bravest, one of the choicest, and one of the most unselfish characters in our literature, a character, who, devout, genial, and altogether lovable, perpetually radiates cheerfulness, courage, and common goodness. As we think of the debut of Mr. Pickwick on the eve of his creator's wedding, we catch ourselves wishing that the felicity that Dickens was preparing for millions of his fellowmen could have been poured into that new relationship upon which he was himself entering.

THE GLORY OF EASTER

It is the distinctive glory of Easter that it imports into the program of the year the soul-stirring note of challenge and of triumph. In deploring the cheerless and disconsolate atmosphere that enveloped the funeral of Robert Browning, Sir Edward Burne-Jones said that he longed to see, somewhere in the black procession, one or two gay, defiant banners, "and much would I have given," he adds, "if a chorister had emerged from the triforium and rent the air with a trumpet!" Easter supplies that exultant quantity. For, at Easter time, we do honor, not to one of life's phases or events or experiences, but to life itself. Easter stands for life at its best, regnant, deathless, immortal. And, in consequence, it produces its stimulating reaction in us all.

Among the subtle but authoritative laws that govern our intricate and complex beings is a law that ordains that the life that pulses within our own veins shall throb with new and startling energy whenever it is confronted by some vivid manifestation of life around or life beyond. The repercussion is so perfectly natural and instantaneous that we often ascribe to external and objective causes a sensation that is really internal and subjective. Wordsworth was once asked why he wrote, and wrote at considerable length, of dancing daffodils.

> ... I saw a crowd,
> A host of golden daffodils
> Beside the lake, beneath the trees,
> Fluttering and dancing in the breeze.

And—

> Ten thousand saw I at a glance
> Tossing their heads in sprightly dance,
> The waves beside them danced, but they
> Outdid the sparkling waves . . .

But, as the poet was obliged to confess when his attention was directed to the matter, daffodils do not dance. They stand perfectly still. Confronted by this embarrassing problem, Wordsworth reflected for some time and then replied that he could only suppose that, since the daffodils set his soul dancing with delight, he had unconsciously transferred the inward sensation to the outward object.

Humanity's Invincible Lust of Life

The thrill with which we greet the return of Easter is but another phase of the same arresting phenomenon. It is life answering to life. In actual fact, man loves life, profoundly and constantly, and every manifestation of the thing that is so dear to him captivates his fancy and sends tremors of gladness through all his being. We love the city because it swarms with life; we love the bush because new forms of life startle us everywhere; we love the play, the film, the novel and the art gallery because, by means of them, we are able to explore new twists and turns of the life that we love. A

similar discovery, on a still more exalted and impressive plane, breaks upon our minds with every recurring Easter. Easter is the supreme festival of life, of resurrection, of immortality. Our nerves tingle in response to its stirring message. In celebrating Easter we are unconsciously giving three cheers for life itself.

It is only man's unquenchable lust of life that enables him to live. In his *Kingdom of Man*, Sir Edwin Ray Lankester directs attention to the remarkable fact that although, compared with the brutes, man is one of the most helpless and one of the most fertile creatures on the planet; he is at the same time one of the most doggedly persistent and one of the most prolific. His birth rate is inconsiderable when compared with the birth rate of the beasts. What then is the secret of his survival and multiplication? Sir Edwin attributes it to his low death rate. His love of life leads him to cling with amazing tenacity to the life that he cherishes. His intense and passionate love of living enables him to endure when all things band together for his destruction. "Even when every natural chance is against him, he insists on saying, and on saying successfully: 'I will live!'" This irrepressible love of life is his most significant and important characteristic.

Man Dares the Thing He Most Dreads

Man is a medley of contradictory qualities. He involves himself in risks that no other creature would face; yet he insures himself, in a way that is possible only to himself, against the hazards that he courts with such intrepidity. Thus, for example, he is the only creature that absolutely declines to be restricted in the scope of his operations by climatic conditions. Other animals have their own

geographical haunts and natural habitats. But man goes everywhere. Neither polar snows nor equatorial suns deter him in his restless wanderings and his alien settlements. Yet, although he displays an audacity that no other creature can rival, and scorns all the limits set, by torrid and by frigid zones, his rate of mortality is the lowest on record. He seems at times to be courting death and destruction; but it is merely a piece of innocent coquetry; he is genuinely in love with life and will ensure any torture in order to retain it.

Nourished by such hopes and aspirations as Easter annually brings, man's passion for living waxes as his physical faculties wane. Men come to feel that death, in any ultimate sense, is unimaginable. The instinct of immensity, infinity, eternity is the light of their eyes and the breath of their nostrils. Immortality is in their blood. In dying, they defy death with the sublime taunt that, though dying, they can never die. They go down to their graves but they go down to their graves with a triumphant Nil Desperandum on their lips. They cry, with Browning:

> If I stoop into a dark tremendous sea of cloud,
> It is but for a time: I press God's lamp
> Close to my breast: its splendor, soon or late,
> Will pierce the gloom: I shall emerge one day;
> You understand me? I have said enough.

It is the peculiar glory of the Easter festival that, once a year, it sounds in the responsive hearts of men that stimulating trumpet blast of unconquerability.

THE HEAD OF THE HOUSE

No family in our literary history has been more talked about and written about than the Brontes; yet one member of that extraordinary household has been consistently excluded from the limelight. And he, strangely enough, is the head of the house, Patrick Bronte, the widowed father of the famous girls. Of the entire group, he is the best worth knowing and we must attempt to make his acquaintance. A genial Irish gentleman with a fairly loose tongue, he loved to talk and had plenty to talk about. One would learn more Bronte lore from him in five minutes than his secretive daughters would reveal in as many years.

A tall, well-knit, handsome old man was Patrick. To the very end, his hair retained a suspicion of the flaming red hue that once characterized it, and his spirit held something of the sparkle of his youth. Was ever a man such a cats-paw of vacillating circumstance? With troubles such as those that, in endless succession, came thundering down on the gloomy old parsonage, and with triumphs like those that, one after the other, his three consumptive girls laid at his feet, poor Patrick must have spent half his time wondering whether he was on his head or his heels.

The Boy is Father of the Man

The more you learn of Mr. Bronte, the more you like him. His very names are interesting. As to his surname, Mr. E. F. Benson declares that Patrick himself manufactured it. As a barefooted little urchin in County Down, his name was Brunty. But Patrick didn't like it; and why should a man be saddled for life with a name that is not to his taste? After the Battle of the Nile in 1799, Nelson, Patrick's peerless hero, was created Duke of Bronte. Brunty! Bronte! How much more musical and dignified! So Patrick made the change. As to his Christian name, there were two reasons for calling him Patrick. He was born on St. Patrick's Day, while a rich uncle, whom it was diplomatic to conciliate, bore that name.

The eldest of 10, Patrick was born in a poor thatched Irish cabin within sight of those Mountains of Mourne that go down to the sea. His body was nourished on an abundance of potatoes and an abundance of milk, while his mind was sustained on the Bible and on *Pilgrim's Progress*. Once in a blue moon, as a rare treat, a microscopic allowance of meat was added to the one pabulum and a few stanzas of *Paradise Lost* to the other. But, as a reference to any astronomical calendar will show, blue moons were very scarce those days.

As a boy, Patrick's clothes were all of them home-made, a circumstance that involved him in considerable derision from boys whose suits had been bought at the city emporiums; and it is doubtful whether, until he was at least 10, Patrick's lower extremities were encased in any kind of footwear. When a vocation had to be chosen, the final selection lay between a blacksmith's shop and a weaver's

shed. His own preference was for the forge rather than the loom; but when it was found that the craft of the smithy involved five years of apprenticeship, while one could become a weaver after serving two, the issue was decided.

Each Man in His Turn Plays Many Parts

As a weaver, Patrick was never brilliant. By this time he had become a diligent student. He read everything that fell into his hands, especially Milton. If fault was found with the warp on Patrick's web, he would plead that Milton's angels and archangels intervened between his eyes and his work. He would declaim whole pages of *Paradise Lost* to the accompaniment of the thud of the shuttle and the whir of the wheels. In secret, too, he was doing a little poetizing on his own account. He looked as unlike a budding laureate as one could possibly imagine; but a selection of these versifyings was afterwards published, together with a few stories—*The Rural Minstrel, The Cottage in the Wood, The Maid of Killarney,* and the rest—and they certainly did him no discredit.

The pontiffs and potentates of that secluded countryside, observing the bent of his mind, secured for him an appointment as teacher at a little school at Glascar. Here Patrick covered himself with glory until, one fatal day, among the corn stacks near the schoolhouse, he was caught kissing one of his senior pupils, a bonny girl with hair as red as his own. Unfortunately, Helen, whose desk was found to be full of Patrick's love letters—some in poetry and some in prose—was the daughter of a local magnate. The thing simply wouldn't do and Patrick had to go.

But it all worked out well. In the year in which he came of age, Patrick was appointed to be teacher at

Drumballyroney; approved himself to everybody; and, probably by means of monetary assistance pressed upon him by the friends he made there, passed four years at Cambridge and inaugurated that academic and clerical career of which we have an outline in the biographies of his illustrious daughters.

He retained to the last his passionate love of his Irish home and of the romantic traditions by which it was encrusted. As long as she lived, he sent his mother twenty pounds a year out of his meager stipend. The loss of his sight was one of the crushing calamities that befell the family in the dark days in which the girls were trying to find publishers for their books. A man of great kindness of heart, a courteous host, a zealous reformer, an able preacher, and a man of wide and catholic sympathies, he was loved and honored by his neighbors and parishioners. His attitude towards his wild and dissolute son was marked by extraordinary tenderness, understanding, and forbearance. His daughters were a constant amazement to him; but he took the greatest pride in their successes.

Losing everybody, he bore his bereavements and his blindness with exemplary courage, and, a lonely and pathetic figure, lingered on in the parsonage until, at the age of 84, he, too joined the host of Brontes that had gone down to the grave before him.

THE HIGH ART OF LIVING

William Law was a good man who developed an extraordinary genius for making other great men good. Here, for example, on a soft autumn day in 1759, two men are lunching together in the hospitable old dining room of the Bull Inn at Putney, enjoying everything but each other's society. They are, indeed, an ill assorted pair. The one is a grave old clergyman; the other, a young fellow of 22, is an obvious dandy. The one is the essence of simplicity; the other is the essence of affectation. Yet both deserve a close and careful scrutiny, for the old gentleman has written a book that has stirred the sluggish conscience of the 18th century to its very depths, while his companion, in spite of the gay kerchief that he so ostentatiously flutters and in spite of the golden snuffbox that he so frequently taps, is destined to become the most renowned historian of all time. For the old clergyman is William Law, the author of one of the greatest religious classics ever written, while the foppish young fellow who shares his table is Edward Gibbon, who has the romance of twenty centuries tucked away among the convolutions of his brain.

Mr. Law, a thick-set, heavily built man, rather above the middle height, is in his 74th year. Although he has, all his life, practiced the habits of a student, and for many years cultivated the soul of an ascetic, he has the face of a farmer, jolly and round, with florid cheeks and grey eyes of unusual brightness. His sturdy figure is inclined to rotundity: his speech is simple but animated: his voice, though soft, easily becomes excited: his whole appearance conveys a subtle impression of immense strength and unfailing kindliness. By what strange freak of circumstance do these two men, having so little in common, chance to be eating together in this quaint old tavern.

Early Impressions Deepen with the Years

They are not strangers. Forty years earlier, Gibbon's grandfather engaged Mr. Law, then in his thirties, as private tutor to his son, the father of the future historian. It is difficult to say which was the better pleased, the old man at having secured the scholarly young clergyman's services, or the ambitious youth at having obtained so congenial an appointment. In that charming home at Putney, the young minister quickly won his way into the affections of the entire household. He was treated as a member of the family, and an honored member at that. There, in the Gibbon home, he spent some of the happiest years of his life; there he received his guests as freely and entertained them as bountifully as if the stately residence had been actually his own; and there he wrote the book that has made his name immortal. About the time of Edward Gibbon's birth, the grandfather died and the home was broken up. But to the very end of Mr. Law's long and useful life all the members

of the Gibbon family kept in closest touch with him.

Gibbon himself was no exception. Although by temperament and training he was unfitted to appreciate the choicest qualities in the character of the devout old man, he made no secret of the profound respect and growing admiration in which he held him. He could not understand Mr. Law's religious views, regarded many of them, indeed, as arrant nonsense, yet, as long as he lived, he spoke with deep emotion of the old clergyman's unwavering integrity and downright goodness of heart. "In our family," Gibbon tells us in his Memoirs, "William Law left the reputation of a worthy and pious man who really believed all that he professed and actually practiced all that he enjoined." And he was often heard to say that the beautiful character of William Law had done more to make the tenets of Christianity credible to him than all the volumes of polemics and apologetics over which it had been his duty to pore. So here they are, this apparently incongruous and ill-matched pair. They stand in striking contrast with each other: there seem to be no standards by which we can compare them: and yet, in his *Res Judicatae*, the Right Hon. Augustine Birrell has essayed the difficult task.

Pair of Masterpieces in Differing Realms

Birrell speaks of Gibbon's *Decline and Fall of the Roman Empire* as a most splendid achievement of learning and industry, a glorious monument, more lasting than marble, to the unrivalled genius of its author. Yet, Mr. Birrell adds, we find ourselves at times in a mood in which *The Decline and Fall* seems but a poor and barren thing by the side

of William Law's *Serious Call,* a book which has proved its power to pierce the hardest heart and tame the most stubborn will. No book, with the possible exception of *The Imitation* by Thomas a Kempis, has influenced so deeply the lives of so many eminent men. It completely mastered the massive mind of Dr. Johnson. John Wesley, Charles Wesley, and George Whitefield—the three leaders of the historic revival of the 18th century—were each, quite separately, profoundly affected by it. Sir John Franklin read it with singular pleasure and profit while waiting for death among the Arctic snows.

The *Serious Call*, Law's masterpiece, is scarcely the book to read for relaxation. "Froude," exclaimed John Keble one day, "you told me that Law's *Serious Call* was a clever book. I have since read it. It seems to me now as if you had said that the Day of Judgment will be a pretty sight!" In that penetrating sentence Keble sums up the situation. Not very long after that lunch with Gibbon at Putney, Mr. Law attended a service on Easter Sunday morning. On the way home, he spoke with rapture of the beauty of the English Spring. A few hours later he was gone. Those who seek the quiet and peaceful spot in which he was laid to rest will have no difficulty in finding it; for it is marked by the monument which Miss Gibbon, the aunt of the historian, erected to his honored memory. It was exquisitely fitting, as his biographer has said, that the body of such a man should be committed to the grave while the old church nearby was still ringing with the echoes of the Easter music, and while Nature all around was unfolding in every opening flower and budding hedgerow her eloquent parable of resurrection.

THE OTHER SIDE OF FOLLY

There is nothing incongruous in the circumstance that, this year, All Fools' Day falls on a Sunday. On All Fools' Day, folly is pilloried; on Sunday, wisdom is preached. The clash of ideas is rather apparent than real. It was to expose men's vices and to encourage their virtues that professional fools were introduced into royal palaces and baronial halls in the days of long ago. That is why Jaques, in *As You Like It,* thought that to be a fool was to be the finest creature breathing:

> A fool, a fool! I met a fool in the forest,
> A motley fool! O, that I were a fool!
> I am ambitious for a motley coat!

The Duke, naturally enough, questions the melancholy Jaques as to why he is so eager for the cap and bells. And Jaques replies that he would fain be a fool because a fool can speak the truth, fearing the face of no man.

One cannot help admiring the sagacity of the medieval peoples in according to the fool this official recognition. No court or castle was complete without its jester. The history of the European fools is in every way an impressive

and edifying record. In the brave pageant of the middle ages there is no figure more striking and attractive amid troubadours, crusaders, knights in shining armor, and lovely ladies gorgeously apparelled, the fool is never put to shame. There he is, with his variegated costume, his flying coat-tails, his pointed slippers, his asses' ears, his gay cap and jingling bells, and all the rest of it! That splash of motley lends distinction and character to a picturesque and memorable period.

Crevices that Admit the Sunshine

It is impossible to resist the conviction that it was in obedience to some sure human instinct that the fool found its way to such remarkable eminence. The fool was a fool, it is true; but generally speaking, the folly of that fool was a little in advance of ordinary people's wisdom. "He is undoubtedly crackt," says Miss Joanna Baillie, in the course of her criticism of Shakespeare's Touchstone, "but then, the very cracks in his brain are chinks which let in the light." Taking Miss Baillie's criticism at its face value, it suggests a curious question. Is it not worthwhile having a few cracks in your brain, if, through those chinks, the light comes streaming? And if there are a few men in the world whose brains, like those of Touchstone, admit the light, ought they to have been banished from mansions and manor houses? Ought they not rather, to be welcomed everywhere?

In his *Poet At The Breakfast Table,* Dr. Oliver Wendell Holmes strikes an even deeper note. "One does not have to be a king," he makes the Old Master say, "in order to know what it is to keep a king's jester." What, precisely, does he

mean? The Old Master is evidently thinking of that inner voice that sometimes speaks in the depths of a man's soul; and he tells of some of the brutally candid criticisms that this second self occasionally addresses to the primary self. "I never got such abuse from any blackguard in my life," he says, "as I get from that Number Two of me. One does not have to be a king to know what it is to keep a king's jester." The point clearly is that, both amid the dazzling splendors of the Court, and amid the awful solitudes of the Soul, the king's jester is the one man who can laugh at the king. It is a fine thing for the king to have one faithful servant who is licensed, when occasion demands it, to look him straight in the face and laugh at him. It is a good thing for us all to be laughed at, at times.

The Value of The Inner Laughter

In his *Les Miserables*, Victor Hugo, with infinite skill, piles up the interest of his monumental story until the overwhelming climax is at last reached. At that terrific climax Jean Valjean has to make his great decision. In reality he is an escaped convict; but he is living under an assumed name, is doing well, is the owner of a vast industry, and is honored and revered by all the townsfolk. He suddenly discovers that a man suspected of being Jean Valjean has been captured. Here, then, is the problem. Shall the real Jean Valjean dash to the ground his own happiness, and the happiness of thousands, by declaring himself? Or shall he maintain silence and allow the other man, who is known to be a scoundrel, to suffer in his stead? Jean Valjean sees clearly what he ought to do. But he cannot bring himself to do it. He resolves on silence and security. "Just then," says

Victor Hugo, "he heard an internal burst of laughter." It was the soul's derision of itself. Jean Valjean was no king; he was a convict; but, as the Old Master declared, he knew what it was to keep a king's jester.

In his *Scarlet Letter,* Nathaniel Hawthorne paints a very similar picture. Hester Prynne, bearing the burning brand of her shame, is exposed to the derision and contumely of the entire populace. Arthur Dimmesdale, the unsuspected partner of her guilt, is everywhere respected and revered. He knows that he should confess the hideous truth and take his place by Hester's side. But he lacks the courage, and, when he decides to remain inactive, he hears, Hawthorne says, a thunderous peal of laughter echoing through all the inner recesses of his being. Arthur Dimmesdale was no king; but he knew what it was to keep a king's jester. Every day his court jester looked him full in the face and laughed at him. It was the laughter of the soul at itself—the most terrible laughter of all. And his court jester gave him no rest day or night until he threw aside all seeming and made his great confession. Then, but not till then, the court jester bowed respectfully to his lord and vanished from the scene.

THE VALOR OF A BRONTË

It was on the last day of March, in the year 1855, that Charlotte Brontë's brief life came to its close. Charlotte reaped her rich reward as she went along. No writer ever owed more to her work than did she. Even in the early stages of her authorship, when the chances of finding a publisher were extremely remote, the manuscript over which she pored so diligently, night after night, rendered her an invaluable service. It gave her a second world in which to live; and nobody needed such an escape more than she did. Her mother was dead; her father was rapidly becoming blind; her sisters were fading away in various stages of consumption; while her only brother kept the stricken parsonage in a turmoil of agitation and terror by his wild and dissolute behavior. In such dispiriting conditions, everything depended on the ability of Charlotte to manage the household, and, at the same time, to earn enough money to keep the wolf from the door.

The only chance that she saw lay in her literary inspiration. She would put it to the test. In such morsels of time as she could snatch from the kitchen and the sickroom, she abandoned herself to her manuscript; and,

instead of finding it an additional strain, it became an exciting relaxation, an unfailing source of comfort, an inexpressible relief. Her friends begged her, for the sake of her health, which was never robust, to desist from this additional task. She would not. "In this vital matter," she wrote, "I must have my own way. The power of imagination lifted me when I was sinking; its active exercise has kept my head above water ever since. I am thankful to God Who gave me this faculty; it is a part of my religion to defend this gift and to profit by its possession."

Triumph of a Girl Who Knew Her Own Mind

The story of the publication of *Jane Eyre* is, as Miss Flora Masson puts it, one of the priceless nuggets of our literary history. Having completed one novel, *The Professor,* Charlotte had sent it to London, but not a publisher would look at it. On the very morning on which she was setting out for Manchester, taking her father to be operated upon, in the hope of curing or mitigating his blindness, the oft-rejected manuscript came back to her once more. "My book finds acceptance nowhere," she says, "nor do I hear any acknowledgment of merit; the chill of despair begins to invade my heart." Yet all this time, Charlotte was working ceaselessly at *Jane Eyre*. At long last *The Professor* was sent to Messrs Smith and Elder. They, too, returned the work, which was never published until after the death of the authoress, but, in returning it, they wrote a letter so full of generous appreciation and shrewd counsel that it entirely neutralized the mortification of still another rejection. If, they said, the author of *The Professor* would send them a three volume novel, they would give it their

most careful consideration. By this time, *Jane Eyre* was half-finished, and, under the inspiration of the publishers' encouragement, the remaining half was soon written.

In several respects, the new novel took a new line. Novelists are all wrong, Charlotte declared, in making their heroines beautiful as a matter of course. "They are wrong; they are even morally wrong; and I will prove that they are wrong. I will show you a heroine as plain and as small as myself, who shall be as interesting as any of theirs." This was saying much, for Charlotte was very plain and very small. Writing as Currer Bell, she some months later sought an interview with Harriet Martineau. Miss Martineau invited her to tea the next day at six. In doing so, she was tortured with conjectures as to the sort of person that Currer Bell would turn out to be, a tall moustached man, an elderly lady, or a girl? But when the hands of the clock pointed to five minutes past six, the door was thrown open, "and in came a neat little woman, a very little sprite of a creature, nicely-dressed and with tidy bright hair. Everybody was charmed with her." On this diminutive self of hers Charlotte modeled her heroine, and the result amply vindicated her contention.

Romance Viewed from the Feminine Angle

Jane Eyre was published in 1847 and took the world by storm. The reviewers did their best to stem the flood. The *Quarterly* hazarded the judgment that, if the work was the work of a woman, it must be a woman who, for some sufficient reason, had long forfeited the society of her sex! Another critic referred to the new author as an alien from society and amenable to none of its laws! But, running

into edition after edition, the book won its own way and soon took its place as an English classic. In one respect it is unique. It is the portrayal of the passion of a woman for a man. In almost all other novels, the love of the man is the active element; the sentiment of the woman is passive. The hero hungers for the heroine; her feelings towards him are scarcely revealed until towards the climax of the story. In *Jane Eyre* the position is reversed. The consuming passion of Jane throbs through every page; it is the attitude of Edward Rochester towards her that remains veiled in obscurity and mystery.

Jane Eyre was followed by *Shirley* in 1849; and by *Vilette*—the most autobiographical of all the novels—in 1853. "There is something almost prenatural in the power of *Vilette*," wrote George Eliot. It was Miss Brontë's last book. In the following year she married, and, a few months later, she died. Her brave struggle against circumstances that would have crushed a less gallant spirit, combined with the purity and excellence of her writings, had the effect of weaving her memory into an exalted and almost sacred tradition. To mention her name was to awaken a choice and beautiful legend. Every thought of her was charged with an exquisite magic. In normal times, a day never dawns on which some party of tourists does not motor across those northern moors to pay a pilgrimage to the little village of Haworth. The visitor forgets its real ugliness in the beauty of the associations that Charlotte Brontë and her two brilliant sisters, Emily and Anne have woven about it. That ceaseless procession of admiring pilgrims is but one of the many evidences of the genuine and deathless affection in which the Brontë tradition is prized and cherished.

TWINKLES AND TEARS

Laurence Sterne is in some respects the most brilliant of all our humorists. It is no wonder that he reached the sober realm of middle life before settling down to his life work. He came of a most extraordinary family. They were incessantly on the move. His father was a soldier, and the regiment was seldom allowed to stay anywhere long. As a consequence, the Sternes lived a kind of gipsy life. They went into a place; stayed there until a child had been born and a child buried; and then jogged on again.

He would be a bold historian who would declare, with any approach to dogmatism, how many babies were cradled and coffined in the course of these nomadic drifts from one garrison town to another. They seem to have lived for a year or so in all sorts of out-of-the-way places, and, with pitiful monotony, we read of their regret at having to leave such-and-such a child sleeping in the churchyard. "My father's children," as Sterne himself laconically observes, "were not made to last long."

Laurence, however, was one of the lucky ones. Entering the world in 1713, he managed to stay here until he was

nearly 55. He spent half his life pondering the marvel of his own excursion into maturity. And, since he was destined to live, he was eager to live to some purpose. While he was still wondering how this end could be achieved, his school master solved the problem for him. Laurence become profoundly impressed by the good dominie's immovable conviction that he himself had been born to greatness.

On one occasion, when the little Yorkshire school room was being whitewashed, a ladder was left on the floor. The temptation was too strong. When nobody was near, Laurence set up the ladder, seized the brush and wrote his name in huge capitals high up on the wall. The usher thrashed him within an inch of his life. But the school master rebuked the usher and ordained that the name on the wall should never be erased. "We shall one day look upon that name with intense pride!" he declared. Sterne says that the music of those words drove from his mind all memory of the thrashing. He secretly vowed that the dominie's dream should be realized.

Achievement Inspired by a Teacher's Confidence

Forty years intervened between the schoolmaster's forecast and the pupil's brief blaze of glory; but during those four decades, Sterne was blindly groping his way towards his dazzling goal. He kept his eyes wide open, his memory keen, and every faculty on the alert. His life was a series of ups and downs, of jolts and jars. He lost his father when he was 18; but a relative, glimpsing those exceptional qualities that had infatuated the schoolmaster, sent him to Cambridge.

On leaving the university he entered the Church,

and fell in love with a particularly charming girl, Elizabeth Lumley by name, who, immediately after their engagement, lost her health and seemed to be hastening to a consumptive's grave. Sterne actually attended what he believed to be her death bed; but in the last extremity of her distress, she rallied, recovered, and they were married.

In magnifying the sly, fantastic wit of Sterne, Carlyle couples his name with that of Cervantes. The author of *Tristram Shandy* stands with the author of *Don Quixote*, Carlyle declares, among the most brilliant humorists that the world has known. And Mr. H. O. Trail maintains that, in the creation of Toby Shandy, English humor reached the loftiest level that it has ever attained.

If, by some fortunate chance, the schoolmaster who welcomed the clumsy little ten-year-old in 1723 lived until 1760, he must have felt that the realization of his dream, though long delayed, was well worth waiting for. *Tristram Shandy* took England by storm. The country was electrified. The work was chaotic; it was incoherent; it was an audacious defiance of all the conventions; but it was captivating, delicious, irresistible. Its startling originality, its grotesque oddity, its rippling whimsicality, set everybody chuckling. Its clownish eccentricities piqued all types of fancy and intrigued every reader.

Pendulum Betwixt Smiles and Tears

Immediately after the publication of his *Shandy*, Sterne went up to London. He was lionized and idolized everywhere. His lodgings in Pall Mall were besieged from morning to night. "My rooms," he writes, "are filling every hour with great people of the first rank who vie with each

other in heaping honors upon me." He proudly and justly observes that never before had such homage been paid to any man of letters. When, a few months later he crossed the Channel, a similar reception awaited him. Paris went wild over him. He was instantly enthroned in the charmed circles of the salons. "My head is turned," he writes to Garrick, "with what I see and the unexpected honors I have met with here." From this dizzy pinnacle, however, he was soon forced to descend.

His life is a strange pendulum, swinging perpetually betwixt the smile and the tear. His health began to fail as soon as he reached the climax of his fame. He continued to write, it is true, and in 1768 published *The Sentimental Journey*. In that same year a company of celebrated writers and their patrons were dining one evening in London. Sterne's name being mentioned, a servant was despatched to inquire after him. "I went to Mr. Sterne's lodgings," this man reported later to the gentlemen assembled at the feast, "and was told to go up to the nurse. I went upstairs, and, while I stood at poor Mr. Sterne's bedside, he died."

Thus, attended only by his own serving woman and the messenger who had just arrived from a dinner party, he passed away; and, a day or two later, only two mourners—one of them his publisher—followed his remains to the tomb. Two days later still the grave was rifled by body snatchers and its contents sold by the thieves to a young surgeon. The literary work of Laurence Sterne is a strange medley of pathos and of humor, but those two antithetical elements are not more oddly mingled in his writings than in his life.

UNVEILING A CONTINENT

It was on March 19, 1813, that David Livingstone was born at Blantyre on the Clyde; and it was on the first of May that he was found, dead on his knees, in his rude grass hut at Old Chitambo's village, near Ilala, in East Africa. Livingstone cuts a Homeric figure in our civilization. It is just as well that most men are content to settle down to the task nearest them, working out their modest destinies without bothering about the distant and the unexplored. But it is also well that each age contains a few adventurous spirits who feel themselves taunted and challenged and dared by the great unknown. They are restless and ill at ease as long as there is a sea uncharted, a mountain unclimbed, a desert uncrossed.

From the moment of his landing on African soil, Livingstone was haunted, sleeping and waking, by visions and voices that came to him from out of the undiscovered. He tried hard, and he tried often, to settle down to the life of an ordinary mission station. It was impossible. The lure of the wilds mesmerized him. He built three houses and left each of them as soon as it was built. The stories that the

natives told of vast inland seas, and of wild, tumultuous waters, tantalized him beyond endurance. The instincts of the hydrographer surged within him. He saw three great rivers—the Nile, the Congo, and the Zambezi emptying themselves into three separate oceans: and he convinced himself that the man who could solve the riddle of their sources would open up a new continent to the commerce of mankind. Few things in history are more affecting than the hold that this ambition secured upon his heart. Even at the last, worn to a shadow, suffering in every limb, and with his feet too ulcerated to put them to the ground, the mysterious fountains of Herodotus teased his fancy and lured him on. And, with death stamped upon his face, he implored his faithful people to carry him as swiftly as possible in his tireless search for the elusive streams.

Exploration, Emancipation, Evangelization

Although he himself regarded his life work as unfinished, and, even in his last delirium, was murmuring wistfully about the unseen waters, yet his record of pathfinding is so astonishing that he takes his place as quite easily the greatest of all explorers. The list of his monumental discoveries covers many pages. When, in 1841, he landed in Africa, the map of that immense continent was a blank from Kuruman to Timbuctoo. When, in 1873, he passed away, that map had been entirely reconstructed. Moreover, his observations were made with such scrupulous exactitude, and his records entered with such microscopic accuracy, that subsequent travelers have been able to find their way from coast to coast with no other assistance than the data that he left.

In spite of all this, however, Livingstone repudiated the suggestion that he was primarily an explorer. He was, first and last, a Christian missionary. He had set his heart upon a redeemed and regenerated Africa, and he never for a moment lost sight of the supreme end towards which all his scientific and exploratory efforts were bent. Whenever he turned his face afresh towards the bogs of the watershed, it was in the fond hope that, by opening up the country, he might blaze a path for the gospel and ameliorate the conditions of the slave. His descriptions of African slavery stirred the anger of the world. The swoop of the pitiless traders on the unsuspecting villages; the blaze of burning huts; the wholesale slaughter and revolting cruelties; and, at last, the long caravan of chained natives driven beneath the lash to the distant coast; all this stirred the imagination of Europe and excited immediate action. "All that I can add in my solitude," he wrote—and the words have since been inscribed upon his honored tomb at Westminster Abbey— "all that I can add is: May heaven's richest blessing descend on everyone, American, English, or Turk who will help to heal this open sore of the world!"

A Drama of the African Jungle

Chitambo's village, the scene of the last moving drama, is one of the loneliest outposts among Africa's boundless solitudes. We have, in fancy, seen the litter on which the explorer's native attendants carried his fevered and emaciated form into the circular hut, shaped like an immense old-fashioned beehive, in which he was destined to close his illustrious career. We all seem to have gazed upon the cold and stiffened form of the man who, dying

the loneliest death in history, was nevertheless impelled by the radiant and palpitating sense of a Presence to struggle, in his last agony, to his knees. We all seem to have stood reverentially beside the tree on which the natives, with uncanny insight, carved the inscription that would enable any white man who desired to do so to identify the spot. Nothing has more impressed the world with the intelligence of the African than the fact that those natives sensed the historic importance of Livingstone; marked the scene of his death in such a way that no fire could deface it; and refusing to bury the body in the wilds, carried it many hundreds of miles to the coast and then accompanied it on its long voyage to Westminster.

Africa has been transformed as a result of Livingstone's exploits; yet, after allowance has been made for the romantic character of his adventures, and the scientific value of his explorations, it is impossible to resist the conclusion that it is not on these grounds that millions of people cherish his memory as one of humanity's most golden traditions. David Livingstone presented to the world the impressive spectacle of a man of the most distinguished gifts, who was prepared to endure any hardship, suffer any loss, or die any death, that he might emancipate and uplift earth's most oppressed races. And when the world finds its prosaic annals enriched by a thrilling story of such practical idealism, it does not willingly allow the name of its hero to sink into forgetfulness or obscurity.

ABOUT THE COVER

F. W. Boreham wrote, "The pulpit is the place for magnificent verities. It is the home of immensities, infinities, eternities." I hope the cover provides a sense of those things because Boreham was fond of being among them, especially those in nature.

Geoff Pound writes, "The skies and seas are featured a lot in Boreham's writings. He saw them as therapy and elements that elevate the spirit."

Everyday life has a way of reducing one's outlook, narrowing our experience. God intends a glorious liberty that is expansive.

The cover is intended to complement what Boreham does in the book. From life's seeming trivialities, he lifts readers to grander themes.

Michael Dalton

PUBLISHER'S NOTE

We are grateful to Dr. Frank Rees at Whitley College for the permission to publish this book and for the practical support given by the College.

A portion of the sale of each book will go toward the training of pastors and missionaries at Whitley College, a ministry that F. W. Boreham supported during his lifetime.

Sincere thanks to Laura Zugzda for cover design and Marcia Breece for layout.

Further information about the life and work of F. W. Boreham is available at the F. W. Boreham Facebook page:

http://www.facebook.com/pages/F-W-Boreham/121475236386.

Please address any comments and questions to:

Geoff Pound

24 Montana Street
GLEN IRIS
Australia 3146
+61 (0) 417 485200
geoffpound@gmail.com

Jeff Cranston

LowCountry Community Church
801 Buckwalter Parkway
Bluffton, SC 29910
jcranston@lowcountrycc.org
www.lowcountrycc.org

Michael Dalton

2163 Fern Street
Eureka, CA 95503
(707) 442-8967
dalton.michael@sbcglobal.net

Printed in Great Britain
by Amazon

58454449R00080